IMAGES
of America

ROCHESTER'S
DOWNTOWN

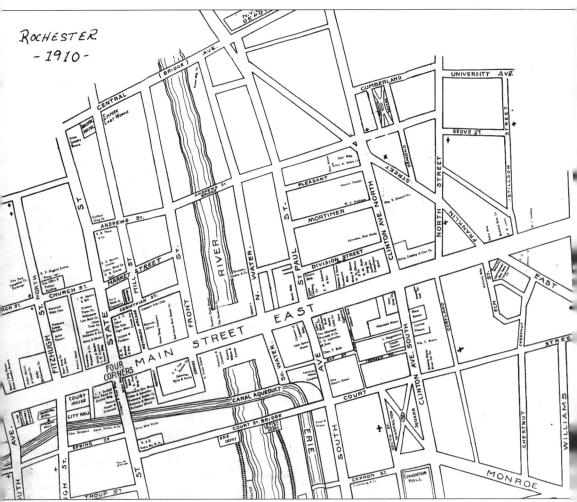

This 1910 map shows a portion of Rochester's downtown, its intersections, and the location of some of its major commercial and civic buildings.

IMAGES
of America

ROCHESTER'S DOWNTOWN

Donovan A. Shilling

ARCADIA

Copyright © 2001 by Donovan A. Shilling.
ISBN 0-7385-0915-9

First printed in 2001.

Published by Arcadia Publishing,
an imprint of Tempus Publishing, Inc.
2A Cumberland Street
Charleston, SC 29401

Printed in Great Britain.

Library of Congress Catalog Card Number: 2001090842

For all general information contact Arcadia Publishing at:
Telephone 843-853-2070
Fax 843-853-0044
E-Mail sales@arcadiapublishing.com

For customer service and orders:
Toll-Free 1-888-313-2665

Visit us on the internet at http://www.arcadiapublishing.com

CONTENTS

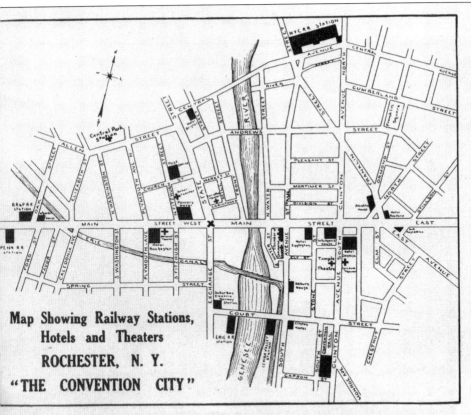

The Rees School was one of the nation's leading institutes for learning the art of engraving. The map, from a page in the school's 1905 catalog, highlights the streets, major downtown hotels, theaters, and railroad stations.

INTRODUCTION

A barometer of the vitality and growth of a community is often displayed by its downtown district. Rochester's main business areas are such a measure of the past and an ever-changing window into its future. Readers are invited to share a unique opportunity to see Rochester's vibrant downtown as it once was. Starting from the west, the photographic images—many from postcards, some from stereographs, others from rare sources—depict the development of Rochester's dynamic principal thoroughfares. Included are images covering its commercial buildings over the years: its theaters, hotels, restaurants, and banks. Also a feature of its Main Street is the city's evolution of its people-movers from the days of horse and trolley cars to its modern bus fleet.

Included are rare views of the interiors of a number of the early enterprises patronized by local citizens over the years. Beyond that are a variety of bird's-eye views of the thriving boulevards. They provide unusual perspectives of the architectural landscape that borders the two-mile expanse between today's Broad Street on the west and Goodman Street on the east.

Perhaps the most unique part of Rochester's downtown Main Street is the point at which it crosses the mighty Genesee River. For years the bridge across the river was faced so solidly with an assortment of shops, banks, and other buildings that newcomers had no idea that a major river was spanned by the street as it ran through the heart of the city. Some even referred to the store-lined bridge as Rochester's Ponte Vecchio. To add interest and enrichment, images of historic playbills from downtown's celebrated theaters are included along with a number of rare hotel and restaurant menus, whose fine food was much enjoyed as a part of Rochester's after-theater dining. Also shown are original invoices providing deeper insight into the growth of the avenue's early department stores. The time frame, 1865 to 1985, brackets much of Rochester's colorful history. Visual documentation is provided of the disastrous Genesee River flood of 1865, the great Sibley fire, and the changing designs of its building facades. Downtown was also the focus for community events throughout the years. These were faithfully recorded through the camera lens, becoming a photograph treasury of the past. Where better to capture on film downtown's remarkable story than in the community that calls itself the "Image City"?

Among those who deserve credit for their much appreciated assistance in providing many of the images included in the book are: George Brown, John Ignizzio, Gerry Muhl, and Fran Warburton. Lending special assistance were Charles Robinson from the Rochester Chapter of the National Railway Historical Society, Jim Dierks from the New York Museum of Transportation, Cynthia Wowk from the Landmark Society of Western New York, and the helpful people from the History Division of the Rochester Public Library. Above all, a special thank you to my wife, Yolanda, whose patient support made this book possible.

—Donovan A. Shilling, March 2001

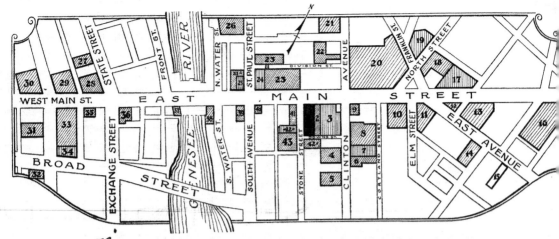

The NEW LINCOLN ALLIANCE BANK BUILDING
and Map of downtown Rochester showing important buildings

1. Lincoln-Alliance Bank Building
2. McFarlin Clothing Company
3. Hayward Hotel
4. Temple Theatre
5. Victoria Theatre
6. B. Forman & Co. (Women's Wear)
7. Lyceum Theatre
8. Hotel Seneca
9. East Side Savings Bank
10. McCurdy & Co. (Department Store)
11. Liberty Building
12. Union Trust Company—East Avenue Office
13. Cutler Building
14. Regent Theatre
15. Rochester Gas & Electric Building
16. Eastman Theatre & School of Music
17. Taylor Building
18. Baptist Temple
19. Proposed new Rochester Savings Bank Building
20. Sibley, Lindsay & Curr Department Store & The Mercantile Building
21. Masonic Temple
22. Piccadilly Theatre
23. E. W. Edwards Department Store
23A. E. W. Edwards Department Store
24. Granite Building, also Woolworth 5 and 10c Store
25. Kresge 5 and 10c Store
26. Chamber of Commerce
27. Ellwanger & Barry Building
28. Powers Building
29. Powers Hotel
30. Duffy Powers Company (Department Store)
31. Municipal Building
32. Terminal Building
33. County Court House
34. City Hall
35. Union Trust Building
36. Wilder Building
37. Democrat & Chronicle (papers)
38. Security Trust Comp
39. Commerce Building
40. Merchants Bank
41. National Clothing Co
42* Open Air Parking Sta
42*
43. Proposed Ramp Garag

In 1926, the officers of the newly erected Lincoln-Alliance Bank Building provided a handy guide to Rochester's downtown. A study of the map opens a fascinating window that reveals the location of many of the area's important buildings during the middle years of the Roaring Twenties.

One

WEST MAIN:
BROAD STREET TO
FITZHUGH STREET

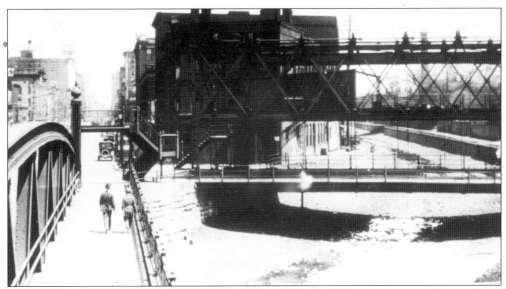

Taken in 1917, this photograph shows the Erie Canal on the right with the West Main Street canal bridge on the left.

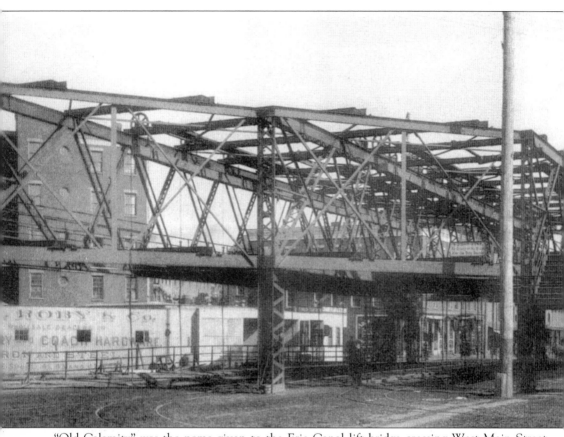

"Old Calamity" was the name given to the Erie Canal lift bridge crossing West Main Street (where Broad Street now intersects West Main). It was often stuck in an up position, creating widespread exasperation among Main Street travelers and an equal amount of ire for canallers when it failed to rise.

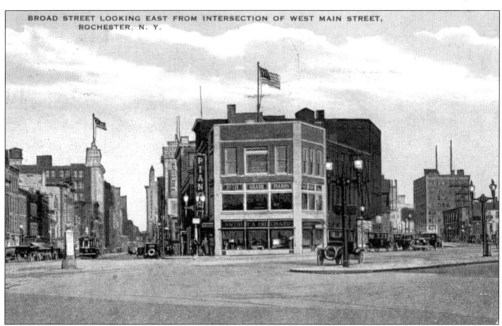

Broad Street, opened on August 14, 1924, was built over the old Erie Canal bed that became Rochester's new subway route.

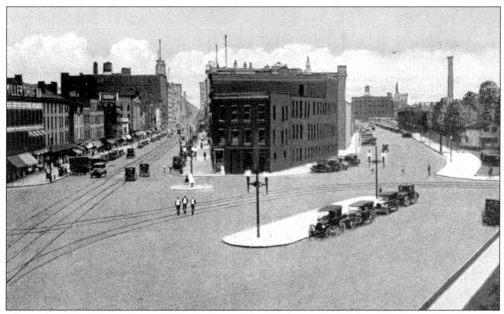

This is the intersection of West Main Street and Broad Street (right) as seen in the 1920s. With the Erie Canal bridge removed by 1921, motorists no longer had to wait for slow barges to pass by or for the bridge to lower.

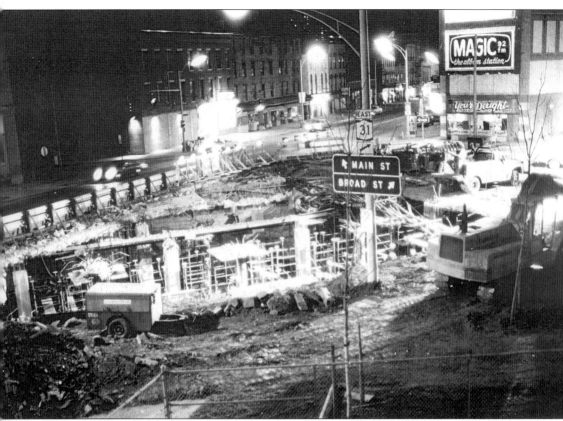

Not known to many, some of the old subway bed still exists under Broad Street. In 1972, work was done to reinforce the bridgelike structure supporting Board Street where it meets West Main Street. (Photograph courtesy Rochester Public Library.)

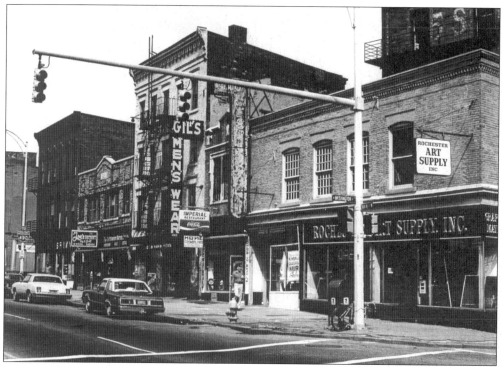

A string of enterprises lined the north side of West Main Street near North Washington Street. This photograph was taken in 1982. (Courtesy Landmark Society of Western New York.)

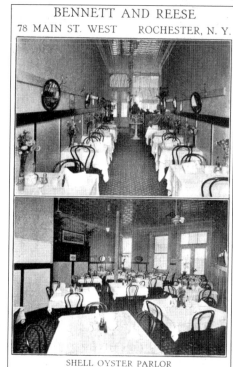

BENNETT AND REESE
78 MAIN ST. WEST ROCHESTER, N. Y.

SHELL OYSTER PARLOR

Dozens of restaurants and saloons once offered food and drink to the crowds who thronged Main Street. One such restaurant was the Bennett and Resse Shell Oyster Parlor, located at 78 West Main Street.

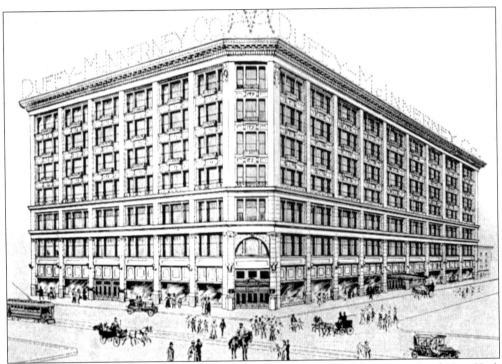

Built in 1907 and billed as the "largest retail store in New York State outside of New York City," the Duffy-McInnerney Company Department Store was located on the northwest corner of North Fitzhugh Street at 50 West Main Street.

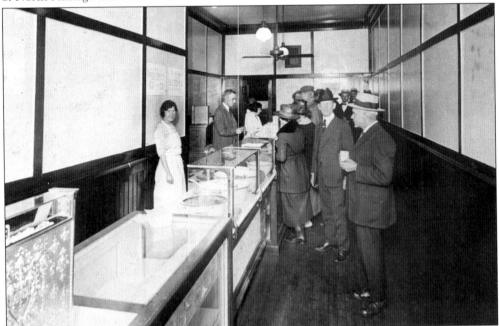

In 1922, one could always enjoy a filling and economical meal at the Home Dairy Company. In its two restaurants, operated at 63 West Main and 107 East Main Street, the food was served buffet style.

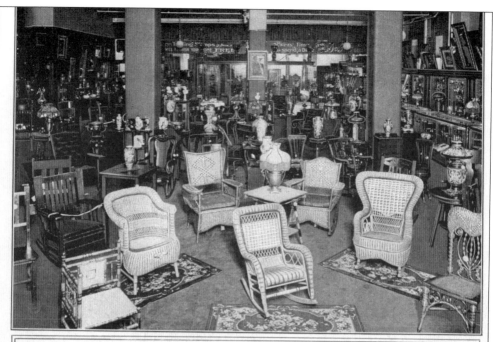

This is an interior view of the *S&H* Premium Parlor on the Fourth Floor of Duffy-McInnerney Co.'s Store, West Main and Fitzhugh Streets, Rochester, N. Y. Every article there is GIVEN away FREE for *S&H* GREEN TRADING STAMPS.

The Best of All Profit-Sharing Plans

IT IS better than a Cash Discount; for you cannot spend the Stamps until you have enough of them to get something excellent— something you will PRIZE and that we will be proud to have you remember us by.

There is no reason on earth why it should not put many, many dollars into your pocket every year.

Another reason why we give you *S&H* Stamps instead of a Cash Discount is that they will get more for you in an *S&H* Premium Parlor than you could buy anywhere else for the equivalent in cash.

Do not forget, however, that all depends upon yourself. If you make purchases and do not get the Stamps, you, of course, cannot get the Furniture, Cut Glass, Draperies, nor any of the thousand other exquisite articles which are given for them.

Here Is Something for You to Remember: — The merchant who gives you Stamps is enabled to get Spot Cash with which to discount his bills and take advantage of the markets. He thus can buy more cheaply; hence, he can, and he DOES, sell you goods more cheaply than ever.

When you make a purchase and fail to get *S&H* Stamps with it, you are actual cash money out of pocket. It is as though you left part of your change on the counter.

DUFFY-McINNERNEY CO., ROCHESTER, N. Y.

A rare 1910 photograph reveals the interior of the S & H Premium Parlor on the fourth floor of the Duffy-McInnerney Department Store. Here, people could trade their Sperry & Hutchinson Green Stamps for furniture, cut glass, draperies, and the other items on display.

Duffy-Powers Company

announces that it has succeeded to the

mercantile business of the

Duffy-Mc Innerney Company

and invites a continuance of your valued patronage

Rochester, New York

July seventeenth 1911

James P. B. Duffy, President

Walter W. Powers, Vice President

In July 1911, the Duffy-McInnerney Company became the Duffy-Powers Company. This unique announcement reports the ownership change to its patrons. The department store was the first in Rochester to take their purchases to a clerk rather than have a clerk obtain the items from behind a counter.

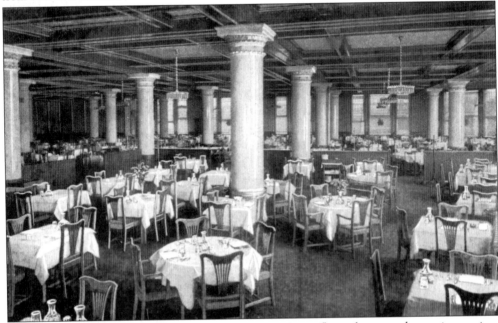

A most unusual feature of the Duffy-Powers Company's top floor, the seventh, was its spacious restaurant, seating 800 diners. On different days of the week, shoppers from different suburban towns were rewarded with attractive discounts.

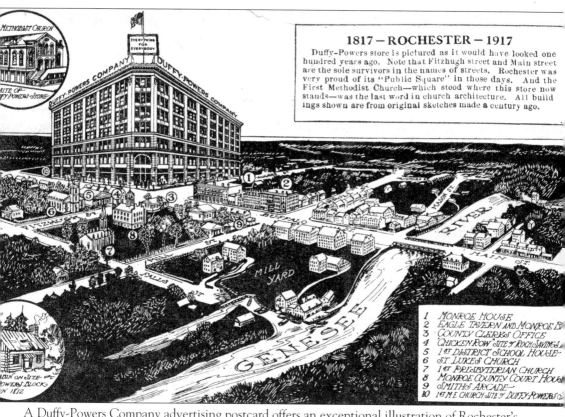

1817 — ROCHESTER — 1917

Duffy-Powers store is pictured as it would have looked one hundred years ago. Note that Fitzhugh street and Main street are the sole survivors in the names of streets. Rochester was very proud of its "Public Square" in those days. And the First Methodist Church—which stood where this store now stands—was the last word in church architecture. All buildings shown are from original sketches made a century ago.

1 MONROE HOUSE
2 EAGLE TAVERN AND MONROE B.
3 COUNTY CLERKS OFFICE
4 CHICKEN ROW SITE OF ROCH SAVINGS
5 1ST DISTRICT SCHOOL HOUSE
6 ST LUKES CHURCH
7 1ST PRESBYTERIAN CHURCH
8 MONROE COUNTY COURT HOUSE
9 SMITHS ARCADE
10 1ST M E CHURCH SITE OF DUFFY POWERS CO

A Duffy-Powers Company advertising postcard offers an exceptional illustration of Rochester's old Buffalo Street (now West Main Street), while locating its department store in the heart of Colonel Rochester's original 100-acre tract. The company closed in 1932.

17

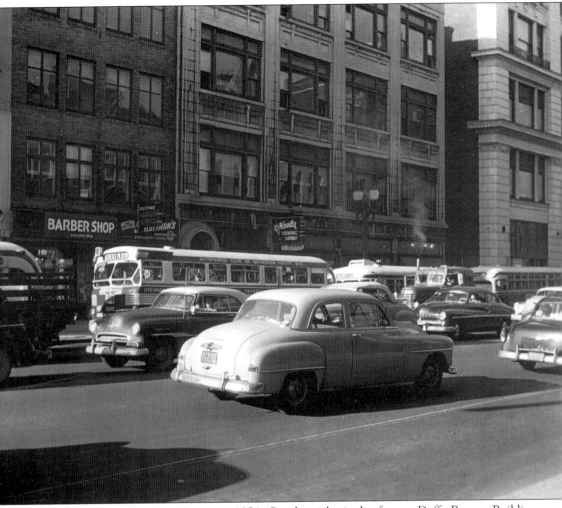

Traffic clogs West Main Street in 1954. On the right is the former Duffy-Powers Building, which the city renamed Civic Exhibits Building in 1942. On the left, traffic passes the Zaccaria Brothers' Barber Shop. (Courtesy Rochester Public Library.)

Two

WEST MAIN: FITZHUGH STREET TO THE FOUR CORNERS

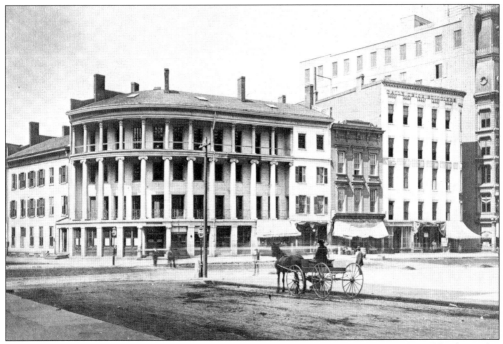

Standing on the northeast corner of West Main and Fitzhugh Streets, the hotel built in the Greek Revival style prior to 1840 was known as the National Hotel and was later known as the Monroe House. By 1881, it was demolished, making room for the imposing Powers Hotel.

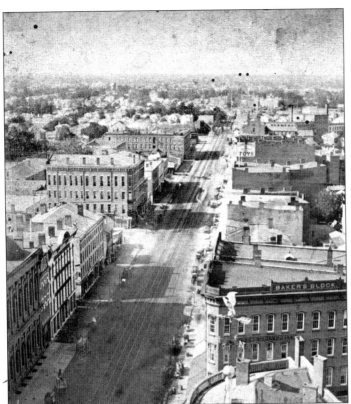

This rare *c.* 1880 stereograph view of West Main Street was taken from the Powers Building tower. Beyond the Erie Canal bridge, the street appears to be largely tree lined and residential. The Baker's Block, on the right, was the home of the Rochester Business University, forerunner of today's Rochester Business Institute.

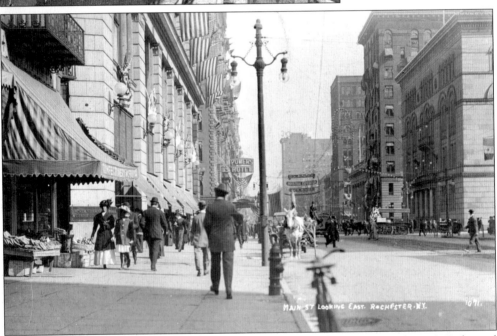

This view looks east down a banner-decked West Main Street during Rochester's Industrial Exposition, October 8–22, 1910. The large building on the right is the Duffy-McInnerney Department Store.

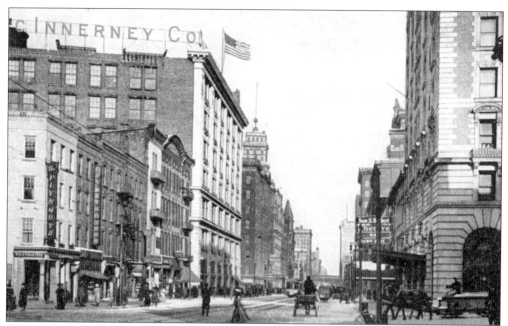

This is a view of Main Street, looking east from the Hotel Rochester as seen through Victorian era eyes. Not even a horseless carriage is in sight. The Sam S. Shubert Theatre is just down the street on the right.

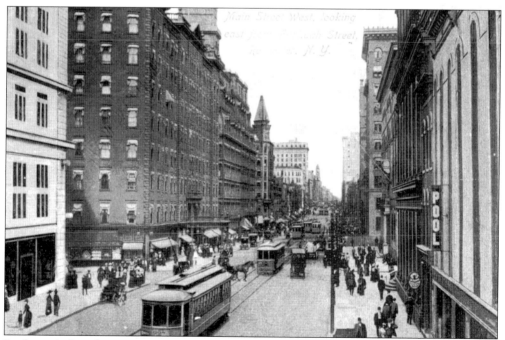

Rochester's first skyscrapers are seen in this photograph looking east from Fitzhugh Street. By 1900, the Rochester Electric Railway had begun its trolley operation down Main Street.

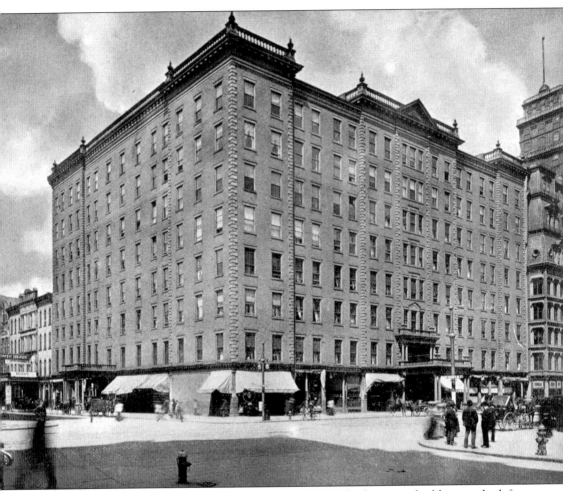

This photograph of the Powers Hotel was taken in 1906. The four-story building on the left, on Fitzhugh Street, is the Baker Theater, a popular playhouse at the start of the 20th century.

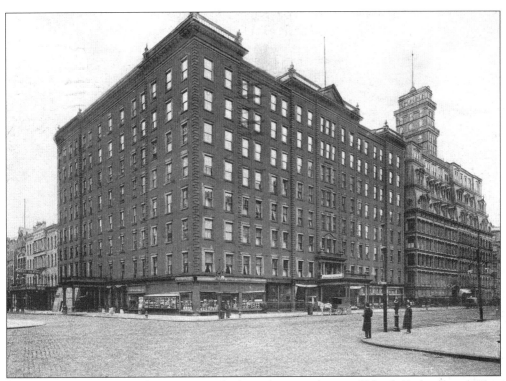

The Powers Hotel, opened in 1883, was built at the intersection of North Fitzhugh and West Main Streets. Critics claimed that the magnificent eight-story hotel was "scarcely equaled in the state outside of New York City."

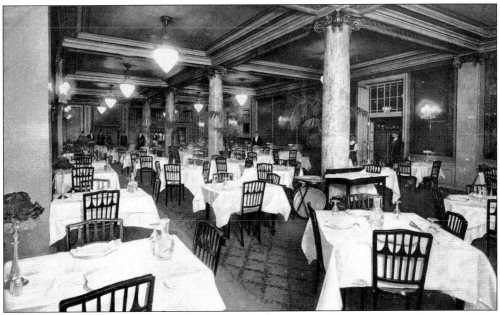

Stiffly starched white linen tablecloths, crystal glassware, and monogrammed serving dishes made dining in the Main Grill Room a memorable experience. White marble columns and potted palms added to the ambiance.

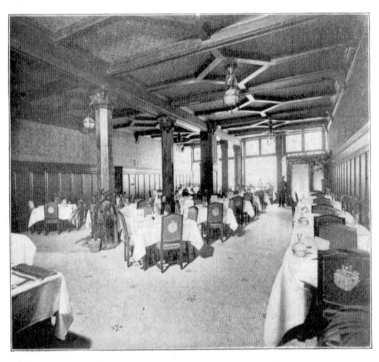

THE POWERS HOTEL NEW CAFÉ.

An 1898 advertisement in the program of the Lyceum Theatre shows the new cafe in the Powers Hotel. Late dinners at the hotel were a favorite after-theater attraction for many years. The Sam S. Shubert Theatre was located just across the street from the hotel.

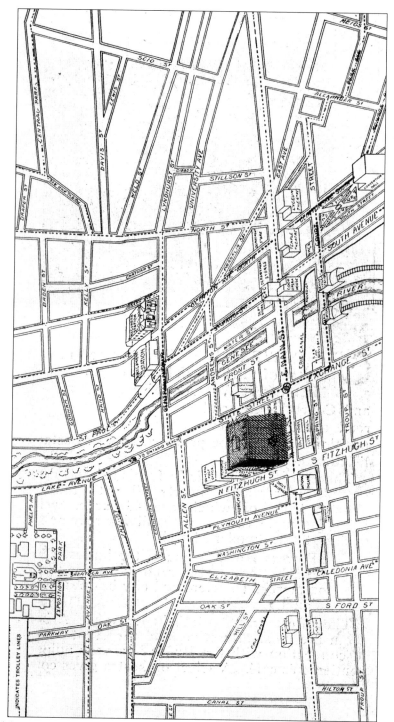

The dotted lines on this 1910 map show the electric trolley line routes and aid in locating the Powers Hotel. At 36 West Main Street, the hotel appears to be neatly centered in the heart of Rochester's downtown. In the 1960s, the hotel was converted into the Executive Office Building.

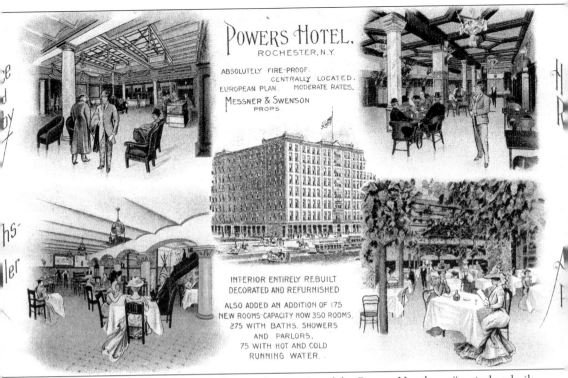

As this c. 1910 envelope cover indicates, the interior of the Powers Hotel was "entirely rebuilt, decorated and refurbished." The 1905 renovation introduced the revolving door and a real innovation: a dishwashing machine. It was considered Rochester's premiere hostelry. Located on Fitzhugh Street is the Baker Theatre, a popular playhouse at the start of the 20th century.

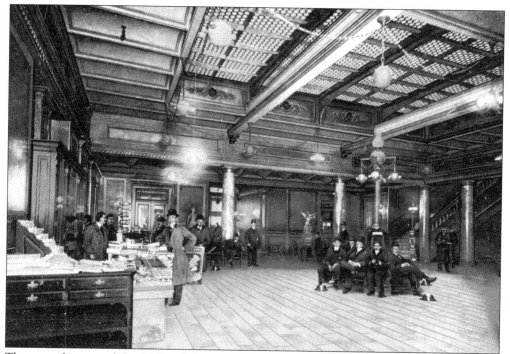

The rotunda, part of the lobby of the ornate Powers Hotel, had marble floors and Victorian statuary. The news and cigar stand is on the left.

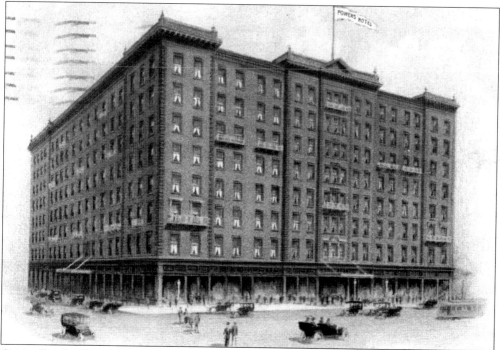

Originally, the Powers Hotel had six stories. Two more were added in 1905. Among those who signed its guest register were Mark Twain, Al Smith, Franklin D. Roosevelt, Babe Ruth, Thomas E. Dewey, Cornelius Vanderbilt, and Lou Gehrig.

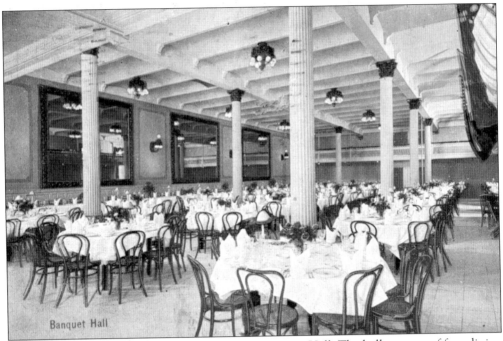

This 1912 photograph shows the Powers Hotel's Banquet Hall. The hall was one of four dining rooms. Messner and Swenson, the proprietors, offered their patrons "elaborate cuisine."

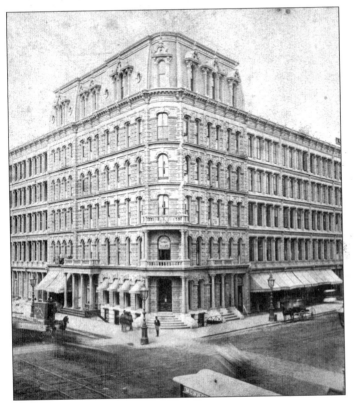

In 1850, Daniel Powers became a private banker in the old Eagle Hotel. After remarkable success, Powers bought the structure and, in 1865, commissioned Andrew Jackson Warner to design a five-story commercial building on State Street. Demolishing the Eagle Hotel, he replaced it in 1870 with a "fire-proof," six-story building with a mansard roof and cast-iron facade. The new building was located on West Main Street at the Four Corners.

To make his building as fire-proof as possible, Daniel Powers built his block with a cast-iron facade, marble floors, wainscoting, and a five-story iron stairway. The grand stairway on the main floor was photographed c. 1885.

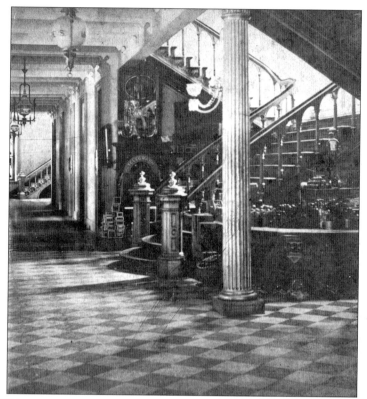

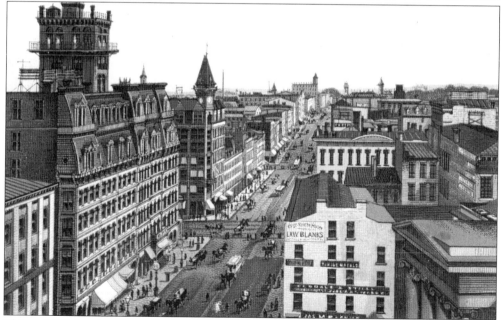

This c. 1880 drawing shows Rochester's Four Corners area in detail. Horsecars made their way eastward up the steep Main Street hill, needing a "helper horse" added at the Four Corners to successfully make climb to St. Paul Street. The second mansard story was added to the Powers Building in 1876.

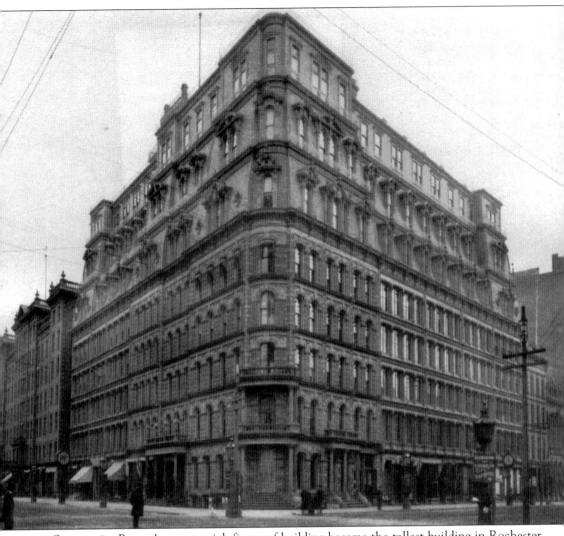

Once again, Powers's commercial, fireproof building became the tallest building in Rochester. To retain this title, the addition of a third mansard story began in 1889. Daniel Powers thought it "added an imposing character" to the structure. A taller tower was also constructed.

One of the unique features of the Powers Building is its five-story tower. It replaced the two-story tower shown in this *c.* 1880 photograph. In 1890, a tower of riveted steel was assembled on the ground and was then hoisted in sections to the roof for reassembly. Extra long bolts anchor the tower through the eighth floor and onto the seventh floor. It was the "highest structure, affording the most commanding view in Western New York." The United States Signal Observatory once operated a weather station here.

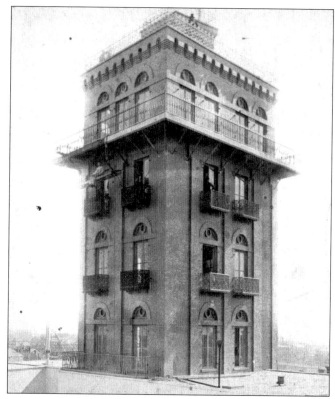

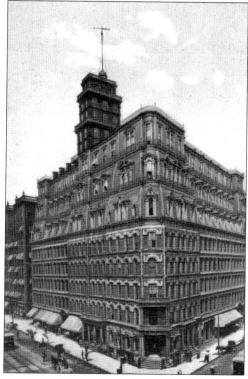

Often called "the grand old lady of Main Street," the Powers Building is seen here with the third mansard roof, which was added in 1890. For a 10-cent admission fee, the public could climb up the tower and get not only a bird's-eye view of much of the city but also a glimpse of the sailboats on Lake Ontario.

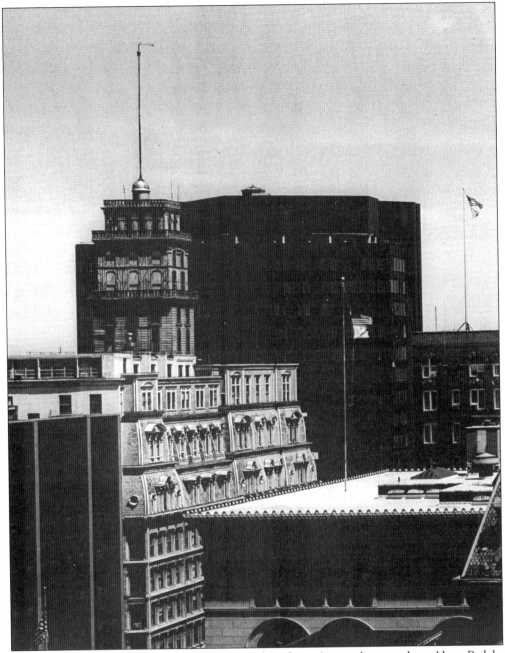

On a crisp, cool day in November 1973, one of Rochester's top photographers, Hans Padelt, took this photograph of the Powers Building, with its three additional stories. The former Monroe County Court House is in the foreground. (Courtesy Landmark Society of Western New York.)

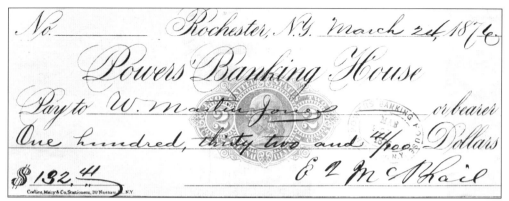

This rare bank note from Daniel Powers's Banking House bears the name of W. Martin Jones. Jones was a prominent Rochester lawyer.

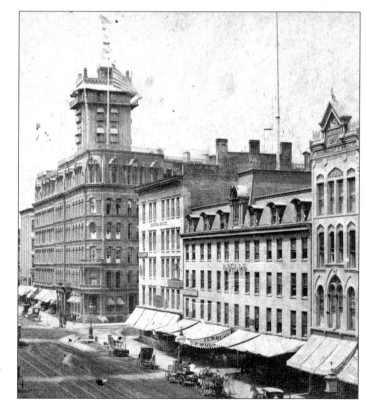

When this early stereograph was taken, the Powers Building had just six stores. The Reynolds Arcade, with its mansard roof, is shown in the center of this *c.* 1880 view.

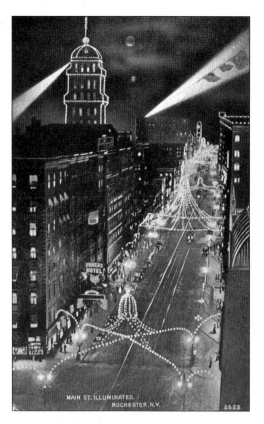

It was August 1912 when Rochester illuminated its Main Street and outlined some of its major buildings with strings of incandescent lights. A Las Vegas-like setting greeted the Odd Fellows when they held a convention in the Flower City during downtown's illumination.

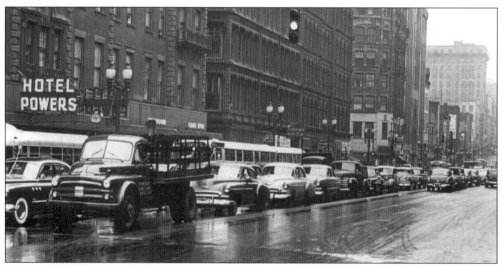

On a rain-slick West Main Street in 1955, bumper-to-bumper traffic inches along during the evening rush hour. Notice the atomic bomb fallout shelter sign pointing into the Powers Hotel. The Café D'Or was a favorite meeting place for those working in the Four Corners area. (Photograph courtesy Rochester Public Library.)

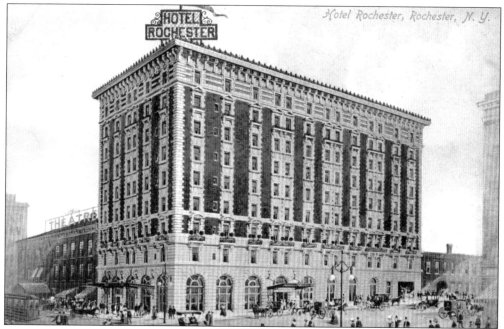

When the old National Hotel on the southeast corner of West Main Street and Plymouth Avenue was razed, a new nine-story hotel replaced it in 1907. The new one was called the Hotel Rochester, and ads reported that its "300 all outside rooms" were priced at "$1.50 per Day up." It had "A Tone all its Own." On December 18, 1999, the once-proud hotel was demolished to create a parking lot

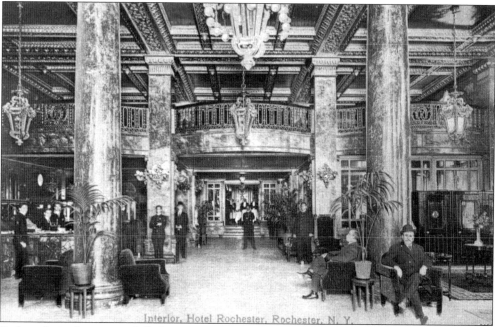

Posh mohair chairs were "all the go" in 1910. The ornate interior of Hotel Rochester's lobby attracted scores of traveling salesmen and large crowds of local folks, who enjoyed the late-hour dinners served after the curtains fell at shows in nearby playhouses.

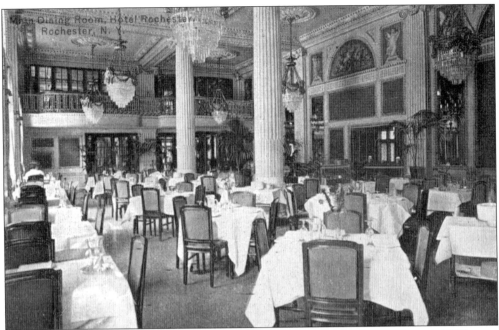

Named for its chandeliers, the Crystal Dining Room was an elegant place to dine. A 1918 menu mentions "Lynn Haven oysters, clear green turtle soup, whitefish fresh from the clear cold waters of Lake Ontario, lobster Newburg, fresh mushrooms under glass, and young guinea hen broiled to a turn with currant jelly, home style potatoes hashed in cream and tips of asparagus."

28th Annual "Kick-In" Dinner
of the
City Engineer's Office
at the
Hotel Rochester
Monday, January 16th, 1939

Wm. H. ROBERST, Commissioner of Public Works
HENRY L. HOWE, City Engineer

YOUR PERMANENTLY RETIRING COMMITTEE
K. I. KNAPP
S. A. CORKHILL
J. A. COLLINS
L. E. LAWLER
F. W. REIDENBACH
R. W. SCHREIBER

Menu

Supreme of Grapefruit, au Rum

Onion Soup, au Gratin

Celery Olives Pickles

Breast of Chicken Eugenie, Under Glass
Melba Toast

Fresh Asparagus Tips
Au Gratin Potatoes

Chef's Salad

Brandy Parfait

Coffee

This menu, printed for the Rochester City Engineer's Office in 1939, reveals that the members enjoyed cuisine that was most acceptable. After-dinner entertainment was a film showing the 1938 Cornell-Dartmouth football game in color.

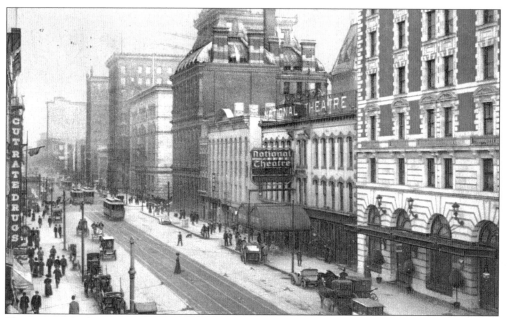

The National Theatre, opened May 18, 1903, was located just east of the Hotel Rochester. The 700-seat playhouse became the Sam S. Shubert Theatre on September, 18, 1911. The building was a mecca for the entertainment of fashionable Rochesterians.

The Fenyvessy Building, at 75 West Main Street, next to the former Hotel Rochester, has been associated with actors since 1902. Originally the National Playhouse, the building was home to the Sam S. Shubert Theatre (1911), Loew's Vaudeville (1915), the Avon Theater (1916), Fay's Theater (1916), the Club Burlesque (1917), and finally Albert Fenyvessy's Capitol.

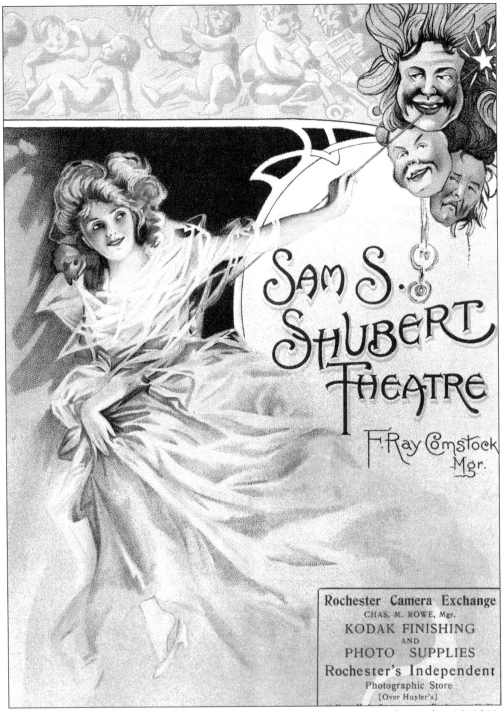

Surviving the funnel of time is this original program given to patrons on September 18, 1911, when the National Theatre became the Sam S. Shubert Theatre. The big feature was a "kinemacolor" presentation of 11 short films. Exciting topics included the unveiling of Queen Victoria's memorial, and the naval review at Spithead.

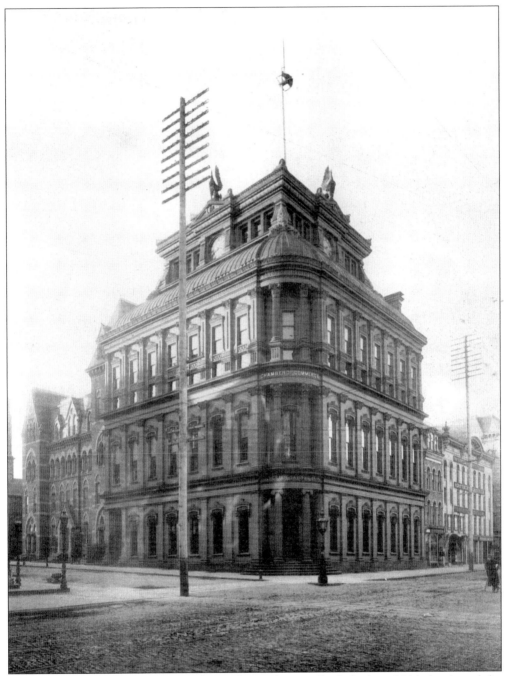

Looking like a fancy wedding cake, the Rochester Savings Bank, built in 1844, dominated the southeast corner of South Fitzhugh and West Main Streets. Located at 47 West Main, it was the leading savings bank in Rochester for years. The Rochester Free Academy, the city's first public school, is on the left in this 1890 photograph.

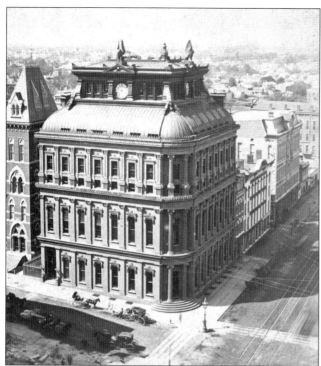

It was 9:35 a.m. when George H. Monroe photographed this *c.* 1892 aerial view of the Rochester Savings Bank from the tower of the Powers Building. Excavation work on the city's third Monroe County Court House at the southeast corner of South Fitzhugh and West Main Street is just commencing.

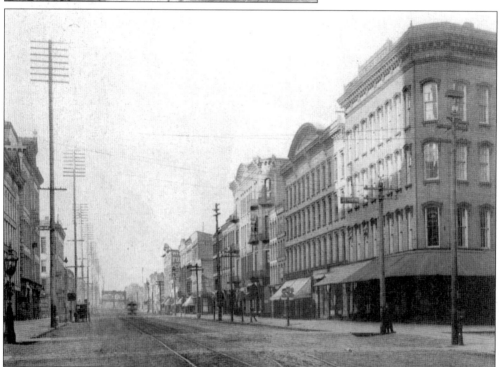

Baker's Block at 50 West Main Street appears in the right foreground of this 1890 photograph, taken from Fitzhugh Street looking west down Main Street. The large bridge in the distance is "Old Calamity." The bridge took Main Street traffic over the Erie Canal.

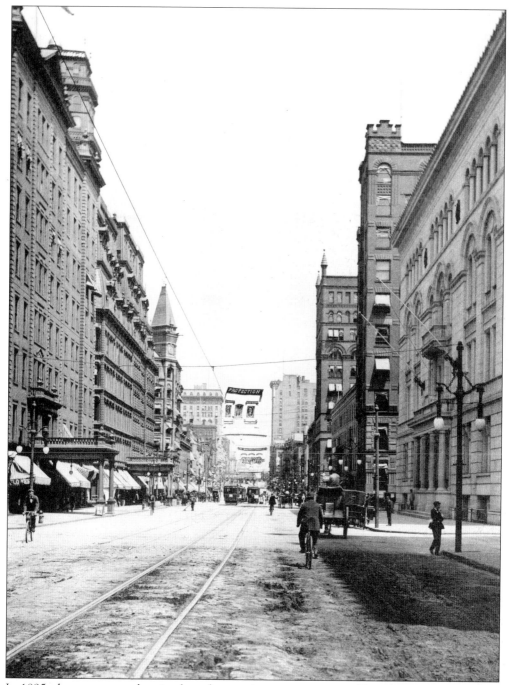

In 1895, there were no wheezing horseless carriages on city streets. Travel appears simpler and slower in this photograph, looking east from the Fitzhugh Street intersection of West Main Street. Banners promote William McKinley and his opponent William Jennings Bryan.

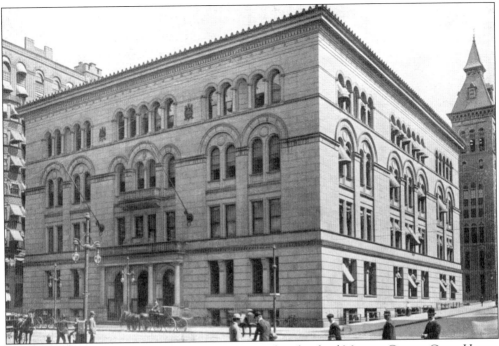

On July 4, 1896, Rochesterians saw the doors opened to the third Monroe County Court House, located at 39 West Main Street on the southwest corner of South Fitzhugh Street. The new, completely furnished courthouse cost $805,008,642. Today, it is known as the Monroe County Office Building. The old Rochester City Hall is seen to the rear.

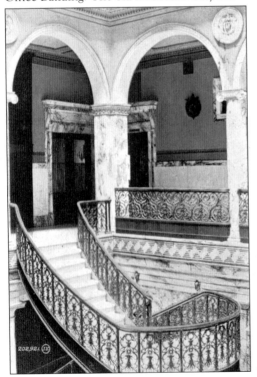

Architect J. Foster Warner designed the former Italian Renaissance-style Monroe County Court House. The second floor is reached by climbing marble steps. The curving stairway's shiny brass railings, intricately wrought with ornamentation, aid the climb.

Richly grained marble columns and graceful Roman arches ring the second floor of the former Monroe County Court House in this Hans Padelt photograph. (Courtesy Landmark Society of Western New York.)

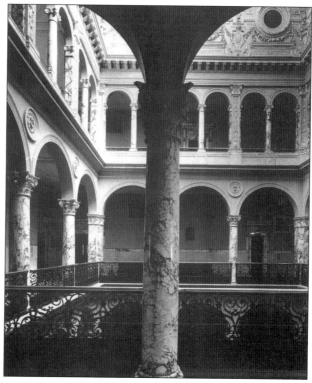

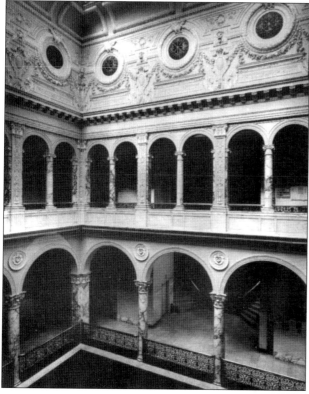

Roaring lions and highly ornate plaster ornamentation greet the eye above the third floor's arches in the city's third Monroe County Court House in this Hans Padelt photograph. (Courtesy Landmark Society of Western New York.)

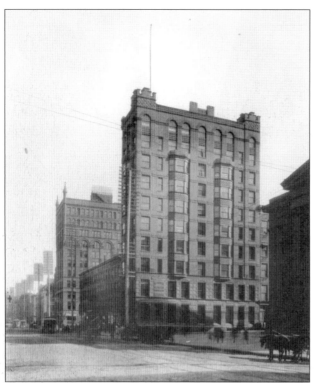

Photographed in 1890, the scene shows a 10-story office building located at 19 West Main. Originally called the German Insurance Building, by 1916 it had become headquarters for the Lincoln National Bank. In 1928, it became the Union Trust Bank Building.

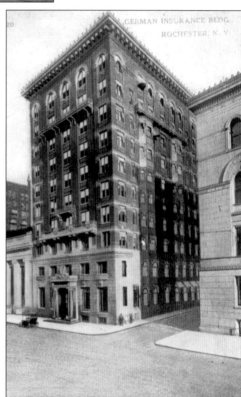

The facade of the German Insurance Building provides a different perspective of the structure. The Monroe County Court House is on the right.

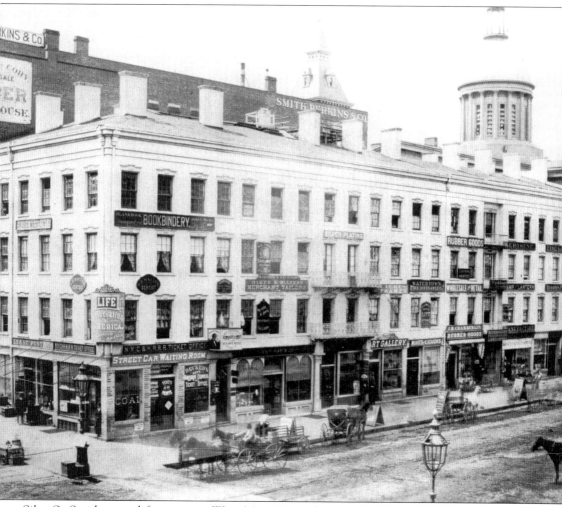

Silas O. Smith owned frontage on West Main Street from Irving Place to Exchange Street. Smith built the impressive Smith's Arcade on the property in 1836. Remodeled several times, it was razed in 1903 to make way for the Rochester Trust and Safe Deposit Company. The city's library benefactor, Morton Rundel, had his art gallery in Smith's Arcade. (Courtesy Landmark Society of Western New York.)

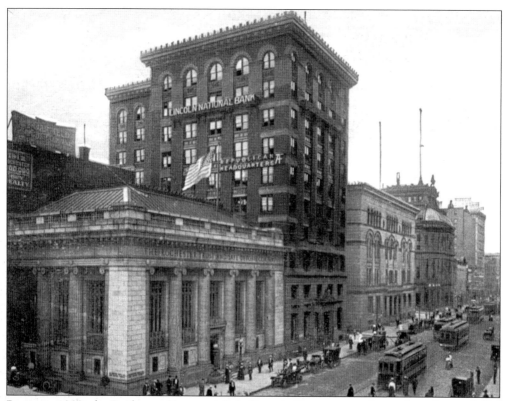

Begun in 1903, the Rochester Trust and Safe Deposit Company was located on the southeast corner of West Main and Exchange Streets. The trust company, located at 5 West Main, was formed from the Powers Bank and merged with the Lincoln Rochester Bank in 1945.

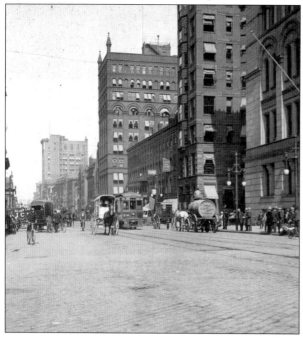

The street water wagon is seen passing a number of the city's finest officers, gathered outside of the Monroe County Court House. This is a 1902 photograph of a typical busy scene on West Main Street. (Courtesy Gerry Muhl.)

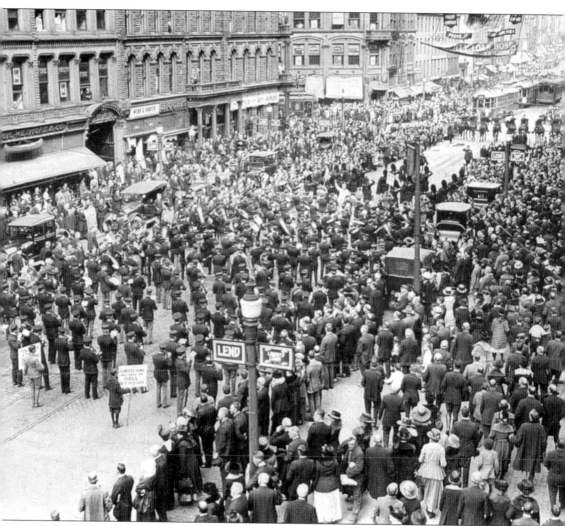

A Liberty Loan rally was in full swing when this scene was captured in 1917. The patriotic citizens of Rochester were asked once again to buy Liberty Bonds during the Nation's fourth bond drive. The crowd and band marchers are assembled on West Main Street just west of the Four Corners. The Scrantom-Wetmore & Company book, stationery, and sporting goods store can be seen on the left in the Powers Building.

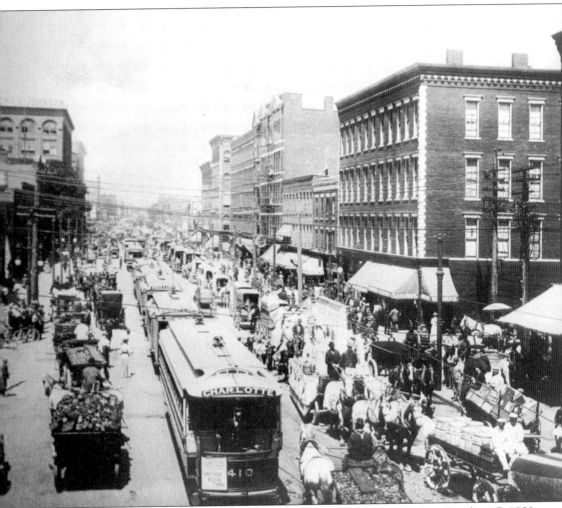

As a part of Rochester's Industrial Exposition, a unique parade was staged on October 15, 1909. Called the Work Horse Parade, a long line of horse-drawn wagons rolled down State Street and up Main Street. The trolley cars had to wait.

Three

EAST MAIN:
STATE AND EXCHANGE
STREETS TO FRONT STREET

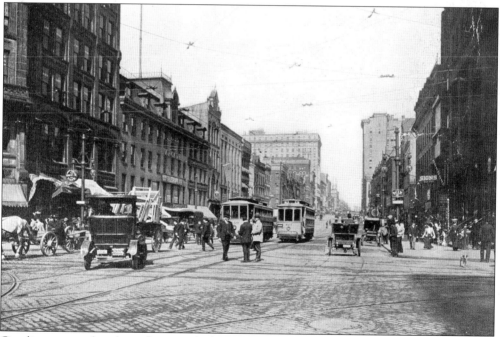

Gasoline-powered tin lizzies have made their appearance at Rochester's Four Corners. Reynolds Arcade is seen on the left, with its mansard roof. The tall Granite and Commerce Buildings are in the center distance.

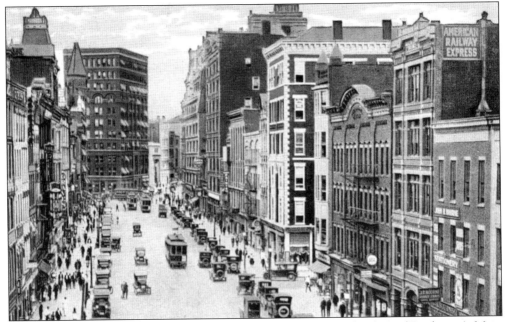

This *c.* 1920 view, looking east from the Four Corners, reveals the face of Rochester's Main Street, which has undergone dramatic changes during the last 60 years.

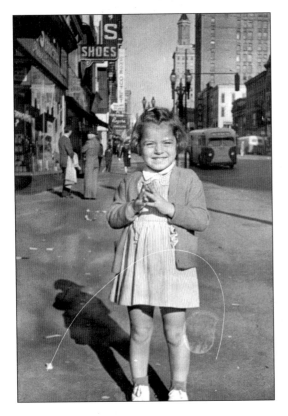

The bright smile on the face of this young shopper was photographed in September 1945. DAW'S Drug Store and Gray's Shoe Store, at 44 East Main Street, are on the left.

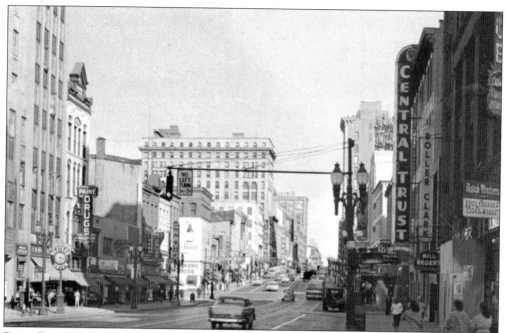

Paine Drugs, Gray's, Lincoln's, Edward's, and other emporiums are all visible in this 1950s vintage photograph, taken from the Four Corners intersection.

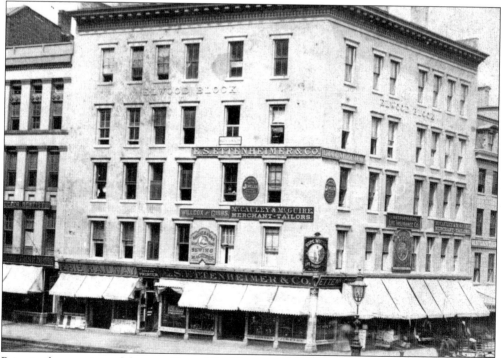

Prior to the erection of the new Elwood Building in 1879, the original five-story Elwood Block appeared as seen in this early stereograph view. Located at the Four Corners, the building occupied the northeastern corner of State and West Main Streets. The E.S. Ettenheimer & Company, selling watches and jewelry, was the chief tenant.

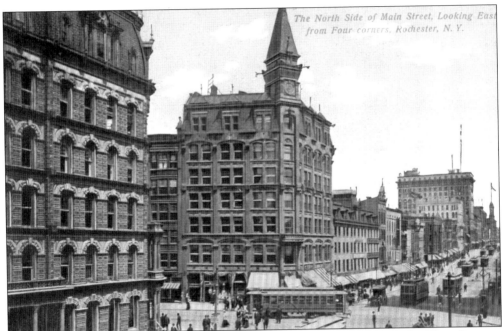

The Elwood Building was one of three early skyscrapers that dominated the Four Corners. Located on the northeast corner of State and Main Street, the seven-story office building was designed by James Gould Cutler, who later became city mayor.

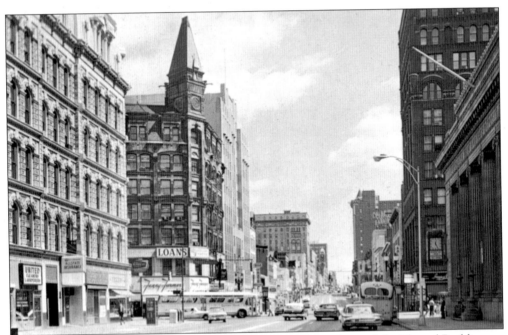

This *c.* 1955 photograph reveals the new Reynolds Arcade just beyond the Elwood Building on the left. The art deco facade stands in sharp contrast to the older Four Corners office buildings. According to the clock on the Rochester Trust & Safe Deposit Company, on the right, the time is 12:25 p.m.

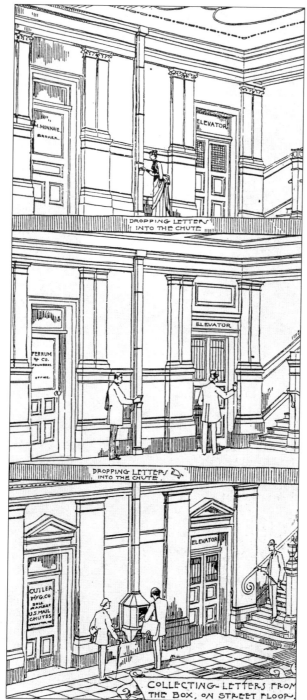

At Frank Elwood's request, James Cutler constructed a metal chute and box for mailing letters from each of the Elwood Building's seven floors. The reliable chute, recognized as such by federal postal authorities, led to the formation of the Cutler Mail Chute Company. Many people working or living in some of the nation's most prestigious buildings still use them, even in this e-mail era.

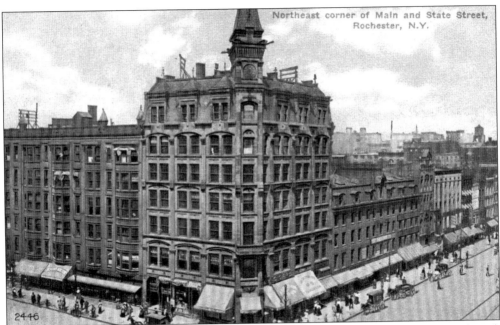

The Elwood Building was a memorial tribute to Isaac R. Elwood by his son, Frank W. Elwood. Isaac Elwood served as secretary and treasurer of the Western Union Telegraph Company. The cost of the Victorian office building was $100,000.

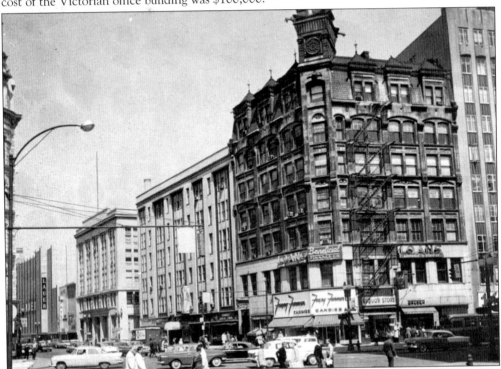

This c. 1957 photograph of the Four Corners intersection looks north down State Street. For many years, the Fanny Farmer Candy Company had its main factory on South Avenue. The Elwood Building was replaced by the 15-story Crossroads office building in 1969.

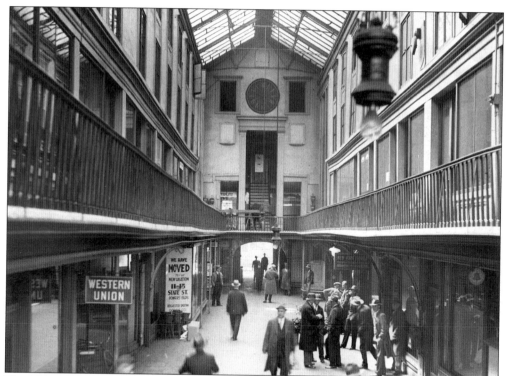

The old Reynolds Arcade was almost legendary. It is said to have been the first covered two-level shopping mall in America. Built by Abelard Reynolds in 1828, it was the birthplace of the Western Union Telegraph Company. This view, looking toward the rear, shows the interior shortly before the mall was razed. A new Reynolds Arcade, with an art deco facade, took its place in 1933.

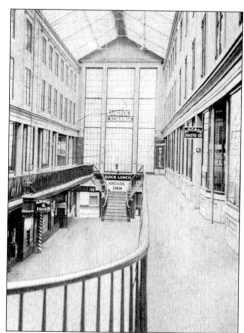

This photograph shows the interior of the original Reynolds Arcade, at 16 East Main Street. The early-1930s view was taken from the front of the arcade.

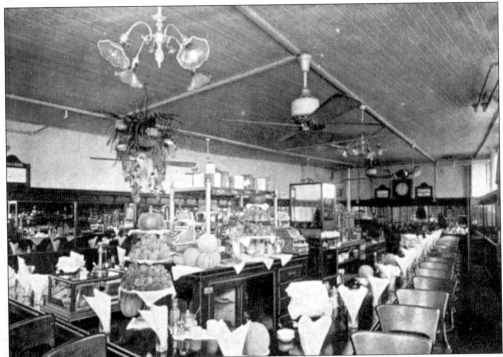

Frances H. Kinney and William M. Johnson ran the Arcade Inn in the 1920s. The melons pictured may well have grown in Irondequoit.

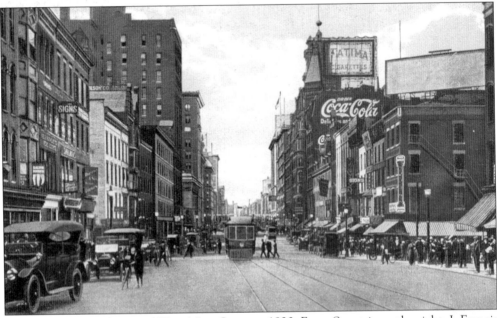

This scene gives a glimpse of West Main Street c. 1920. Front Street is on the right. J. Francis Galvin's dentistry office, at 65 East Main Street, can be identified by the sign on the left that is in the shape of a huge white molar.

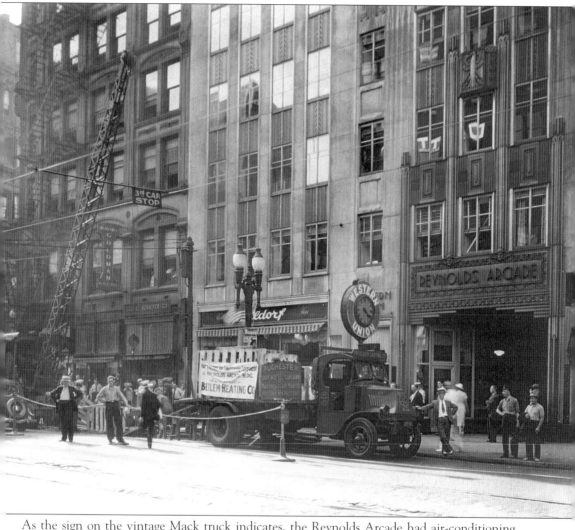

As the sign on the vintage Mack truck indicates, the Reynolds Arcade had air-conditioning installed by the Betlem Heating Company. (Courtesy Rochester Public Library.)

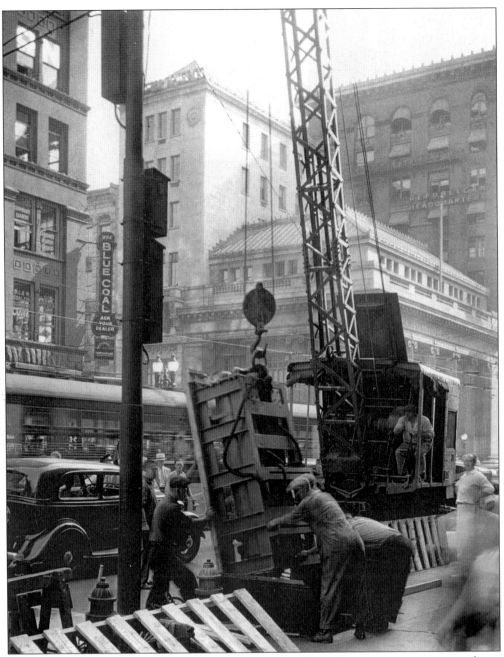

Sidewalk superintendents watched the action at the Four Corners, as a crane raised air-conditioning components into the Reynolds Arcade building, at 19 East Main Street, in 1940. How many residents remember their "Blue Coal" dealer? (Courtesy Rochester Public Library.)

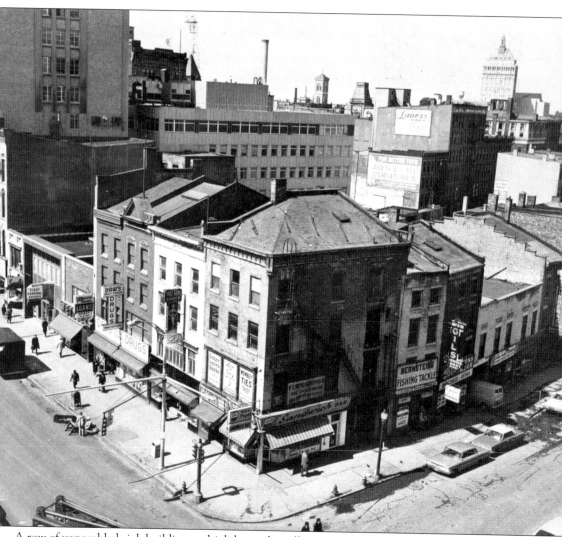

A row of venerable brick buildings, which housed small stores, once prospered on the northwest corner of Front and West Main Streets. The Reynolds Arcade building is on the left, and the Kodak office tower is on the right in the distance. Urban renewal replaced this site with the First Federal Building—distinctive because of its sombrero-shaped revolving restaurant.

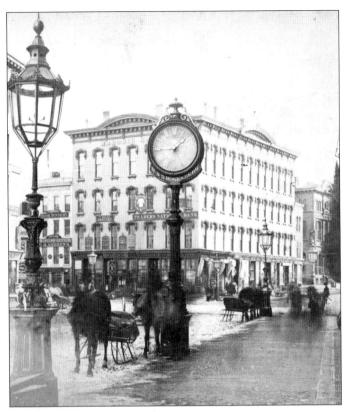

The Chappell Block stood on the southeast corner of West Main and Exchange Streets, which is the site of the Wilder Building today. The view looks across Main Street from the Powers Building on State Street. From 1861 to 1872, the top floor of the Chappell Block was used as the Masonic Hall. Smith's Arcade adjoins the block on the left.

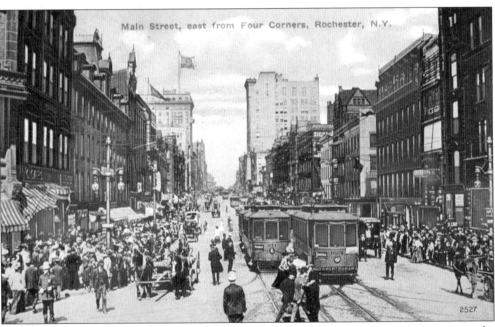

It appears that the crowd assembled at the city's Four Corners intersection is enjoying a parade. The parade, made up entirely of horses and wagons, is heading west down Main Street. In this 1911 view, a similar line of wagons is parading eastward.

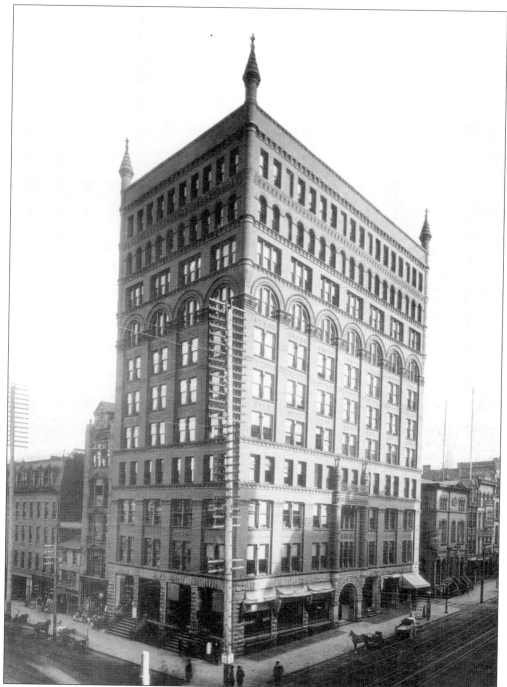

The Wilder Building was built in 1887 for Samuel Wilder, founder of the Central Trust Company. Located on the southeast corner of the Four Corners, the formidable 11-story, red-brick structure has 176 offices, a cast-iron stairway, and marble floors. When completed, the building's 11 stories won the title of the tallest structure in the city. Across Main Street, Daniel Powers soon replaced his building's tower by hoisting a new and taller one to recapture the Powers Building's place as the city's loftiest.

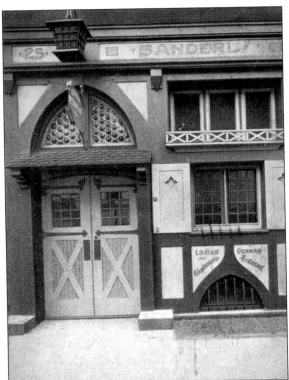

Rochester's large German population enjoyed eating at Sanderl's German Restaurant, at 29 East Main Street. The restaurant's exterior radiates its Teutonic origin.

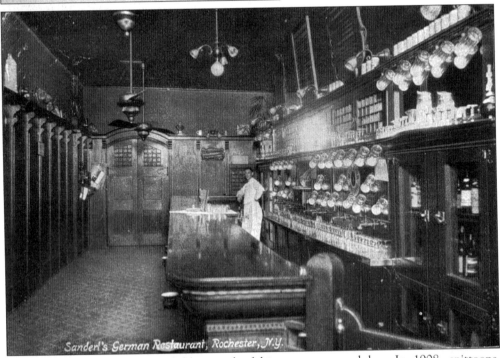

Alphonsus B. Sanderl is justifiably proud of his restaurant and bar. In 1908, spittoons, a marble bar, and lines of heavy glass schooners for dark German brew decorated the rear of the restaurant.

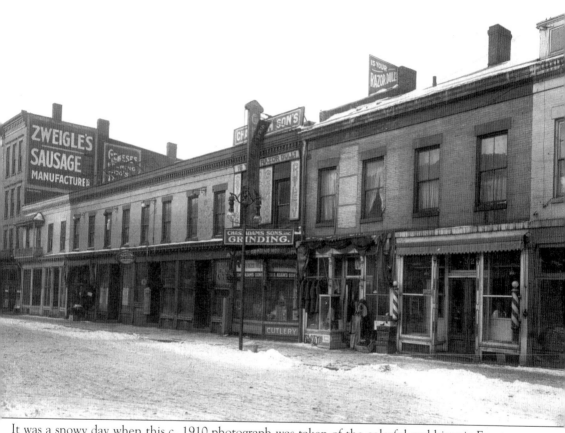

It was a snowy day when this *c.* 1910 photograph was taken of the colorful and historic Front Street. Bordering the west side of the Genesee River, it became a street of saloons, clothing shops, pawnshops, and inexpensive restaurants. It was also the popular place to purchase choice meat and poultry. No city street had a more checkered history. It was home to the People's Rescue Mission, and the Salvation Army Band often performed at its Main Street corner.

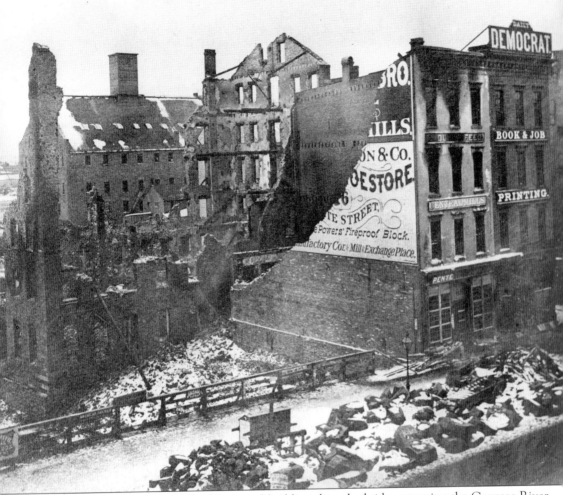

The fallen brick and rubble of destroyed buildings line the bridge spanning the Genesee River where it was crossed by Main Street. The devastation is the result of water, not fire. The image is a copy of an original photograph taken in 1865 to document the city's worst flood. The photograph was taken looking north, with the river on the left.

Four

EAST MAIN: FRONT STREET TO ST. PAUL STREET AND SOUTH AVENUE

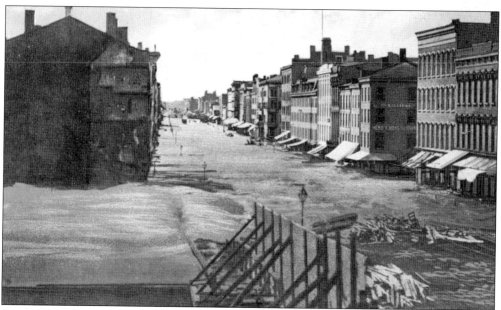

On St. Patrick's Day in 1865, Rochester suffered its most destructive flood. Spring floodwaters poured down the Genesee River, roaring through the West Main Street area. The flood washed away many of the buildings perched along the bridge spanning both sides of the river. Its rushing waters filled the basements and first floors of dozens of shops from St. Paul Street to the Four Corners. This view is looking west from the Main Street bridge.

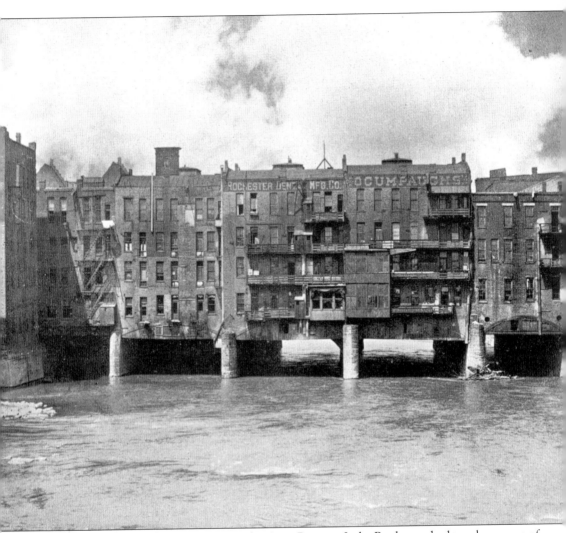

Like the venerated Rialto Bridge over the Arno River in Italy, Rochester had two long rows of mercantile buildings bridging its river, the Genesee. Newcomers were often unaware that a large river, completely hidden from Main Street traffic, flowed under Rochester's main commercial artery.

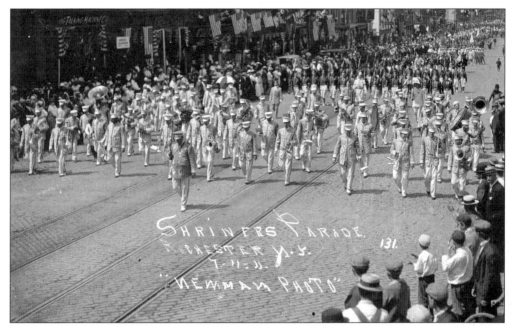

Rochester's Main Street was lined with spectators, as the Shriners marched by in a huge convention parade on July 11, 1911. Dressed in spiffy white uniforms, one of the band units is seen passing the Taking Machine Company, at 97 East Main Street. It was one of several stores that rested above the waters of the Genesee River at this point.

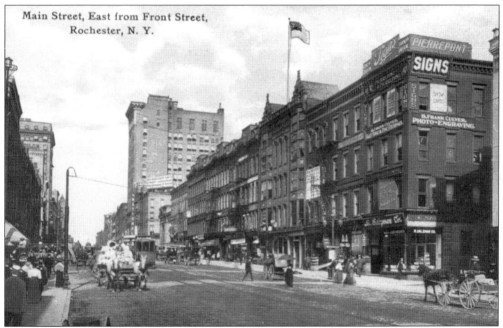

Looking east up East Main Street from Front Street, it is hard to believe the buildings on either side of the street were actually built on girders spanning the Genesee River. The entrance to South Water Street is on the right.

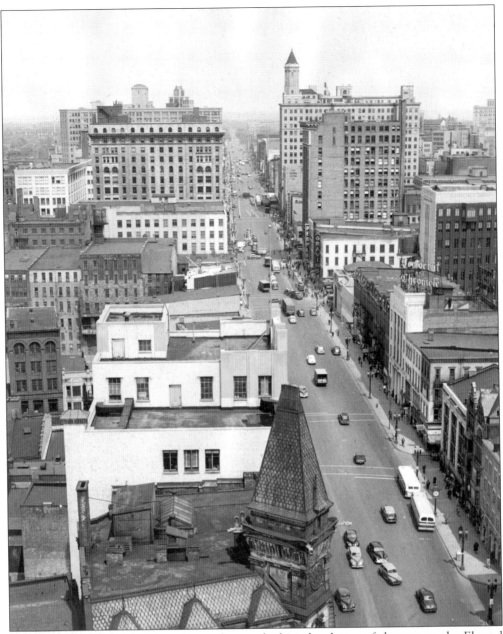

This late 1940s photograph provides a close-up look at the slate-roofed tower on the Elwood Building, with its gargoyle water spouts. Farther east on the Main Street Bridge, the Democrat & Chronicle Building and the Royal Uniform store can be identified on the right. Visible on the left are the backs of the old stone buildings between the Genesee River and Water Street. Front Street is also on the left, hidden beyond the Reynolds Arcade.

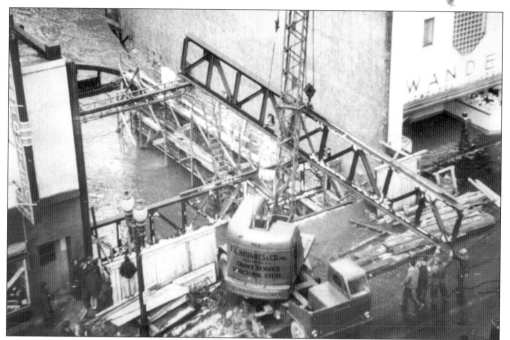

As a part of Rochester's urban renewal program, the buildings spanning the Genesee River were razed. Here, one of the supporting girders is being removed by F.L. Heughes & Company. The Manufacturing Shoe Outlet, at 64 East Main Street, is on the left. (Courtesy Shaw Brothers Collection.)

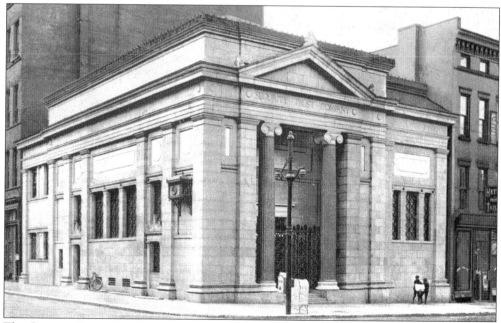

The Security Trust Company was located on the southwest corner of East Main and South Water Streets. Founded in 1892, it became the North Star Bank in 1984. The building was demolished to make way for the Convention Center. Two of its impressive Ionic columns were placed within the new center.

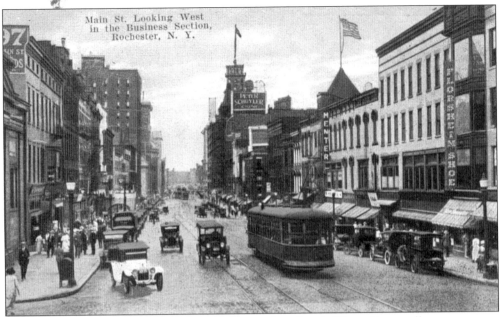

This 1920s view, looking west down Main Street from South Water Street, allows one to see the buildings that completely hide the Genesee River from Main Street traffic. The Security Trust Bank is on the left. The Menter Company sign, seen on the right, advertised a credit clothier store.

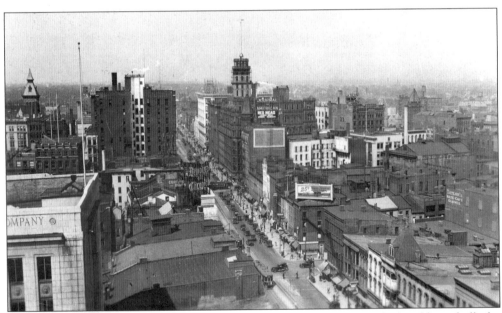

Careful study of this unusually clear bird's-eye view, looking west, reveals the old city hall, the Duffy-Powers Block, and other downtown buildings. Security Trust Company is in the foreground of this c. 1920 photograph.

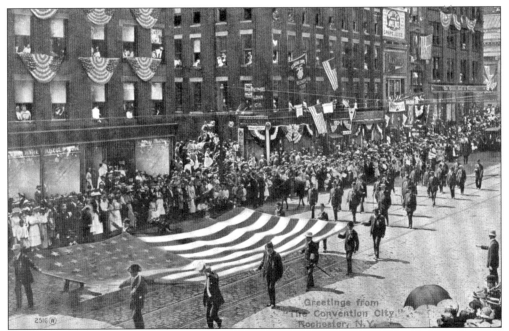

The Grand Army of the Republic (GAR) holds its convention in the Flower City *c.* 1905. Civil War veterans carry Old Glory up East Main Street, passing crowds near Exchange Street.

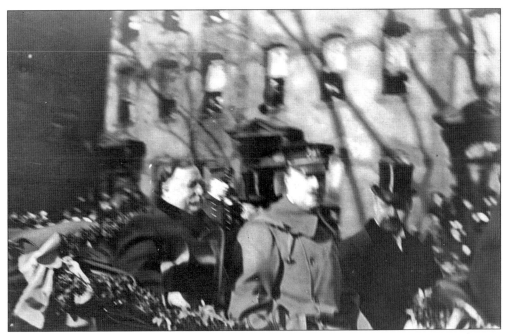

Pres. William Howard Taft attends the Grand Army of the Republic Convention in Rochester, held in 1911. In the carriage from left to right, are Taft; Major Butts, who lost his on the *Titanic*; and Hiram Edgerton, mayor of Rochester. (Courtesy George Brown Collection.)

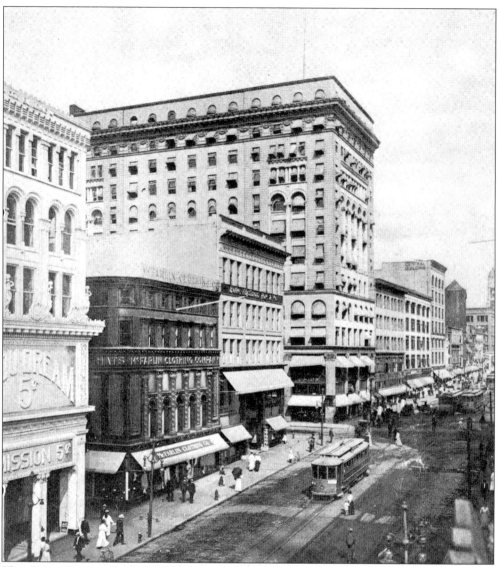

The Bijou Dream, Rochester's first nickelodeon, opened in the summer of 1906. The six-story theater, built in 1890 at 106 East Main, closed in 1913. Just east of it was the McFarlin Clothing Company. For many years, the clothing company was one of the city's prominent men's stores. A major hotel fills the site today. This photograph was taken looking east toward the Granite Building.

One of Rochester's most distinguished men's clothing stores was the McFarlin Clothing Company. This rare postcard allows one to see what the original store, at 110 East Main Street, looked like.

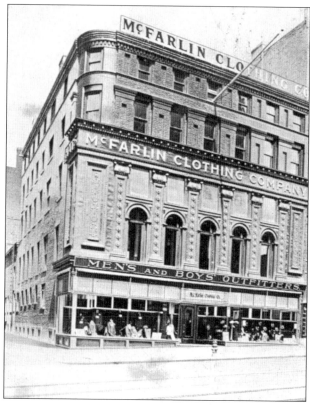

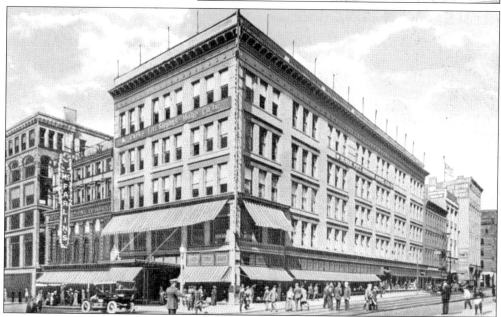

A premier department store at the start of the 20th century, Burke, FitzSimons, Hone & Company operated its impressive five-story building on the southwest corner of St. Paul and 122 East Main Street. In 1886, the store billed itself as "the Largest and Most Reliable Wholesale and Retail Dry Goods, Millinery, and Carpet House, in Western New York."

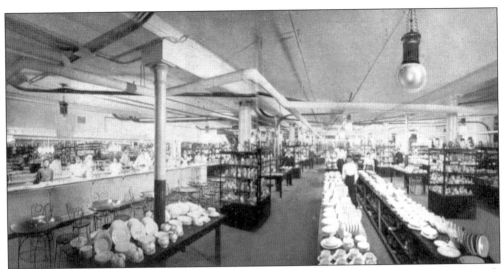

While men's and women's clothing was the principal offering of Burke, FitzSimons, Hone & Company, a cafeteria and an overflowing line of china, crockery, and other notions filled the store's basement. Note the fancy lighting fixtures.

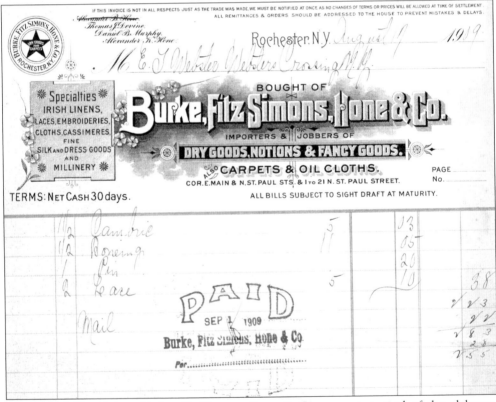

The 1909 billhead from Burke, FitzSimons, Hone & Company is typical of the elaborate decoration that was a part of the Victorian era—even in its paperwork. When young people went off to college, they were often outfitted at the popular department store. The Burke Building site is currently occupied by the hotel chain known as the Four Points by Sheraton.

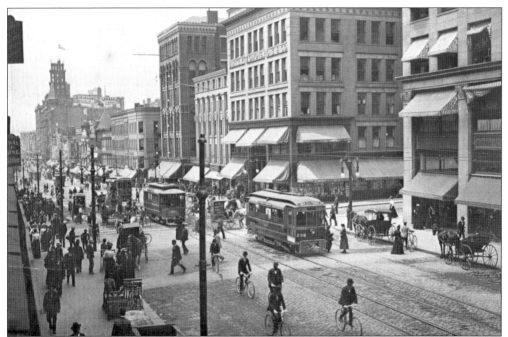

Just before the turn of the century, the bicycle craze hit Rochester. Here a bicycle "club run" is wheeling its way up East Main Street past the St. Paul and South Avenue intersection. The Burke, FitzSimons & Hone Company Building is seen on the northwest corner of St. Paul Street. This view looks west.

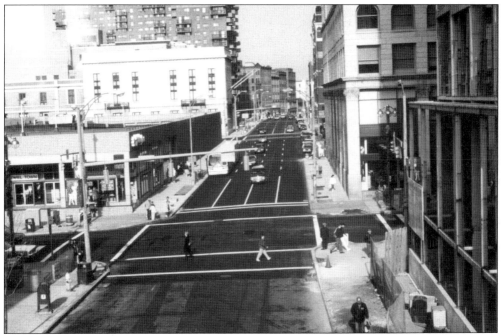

In the early 1990s, the intersection of South Avenue, and St. Paul and East Main Streets looks far different from photographs taken in the pre-urban renewal era. On the right, the Hyatt Hotel is under construction.

18	Mohair		5/-	11	25
2	Drill		/14		28
2	Silk		10/	2	50
1	Shields	25 and 13			38
1⅙	Buttons		55		64
3	Spools		1/		34
2		@6 12 @3 06			18
1	Braid				07
14	Print		9	1	26
8ª	Cambric		8		68
				$17	61

The great Sibley, Lindsay & Curr Company dry goods store began in 1868 at 73 East Main Street in a building called the Marble Block. By 1875, the store occupied the two buildings shown on the ornate billhead seen here. In later years, the H.L. Green Company had a store on that site.

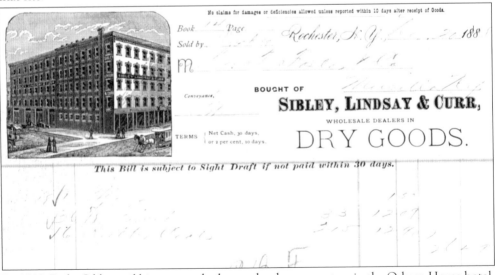

By 1888, Rufus Sibley and his partners had moved to larger quarters in the Osborn House hotel, at the northwest corner of St. Paul and East Main Streets. The renovated building now boasted 600 employees.

Five

EAST MAIN: ST. PAUL
STREET AND SOUTH AVENUE
TO CLINTON AVENUE

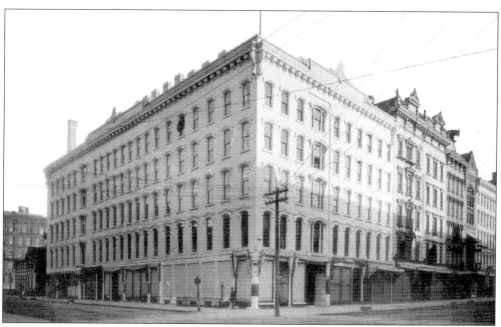

The Osborn House Block, built *c.* 1856, was once home to the finest and proudest hotel in Rochester. The building, located on the northeast corner of East Main and St. Paul Streets, became a commercial block housing Sibley, Lindsay & Curr in 1880. In 1893, the block was replaced by the Granite Building, with Sibley, Lindsay & Curr as the major tenant.

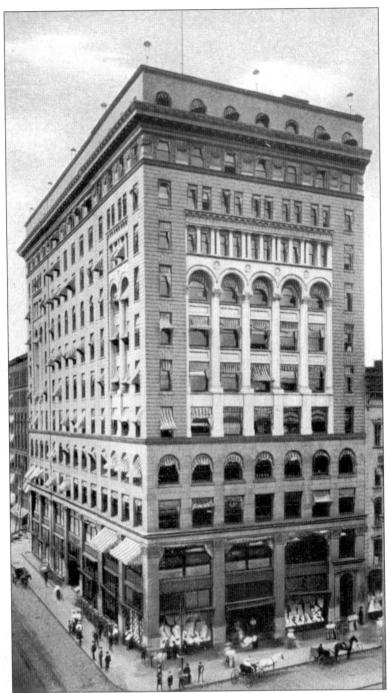

Built in 1894, the 11-story Granite Building at 85 East Main Street, named for the quantities of granite used in its construction, is believed to be the first local structure to use a steel frame in its erection. In quality of construction and degree of interior excellence, it "was unequaled in Western New York." Sibley's, the building's major occupant, had three junior partners: Thomas S. Johnson, Andrew J. Townson, and Thomas B. Ryder. The three men became directors. By 1903, the burgeoning dry goods store had made plans to build even larger quarters.

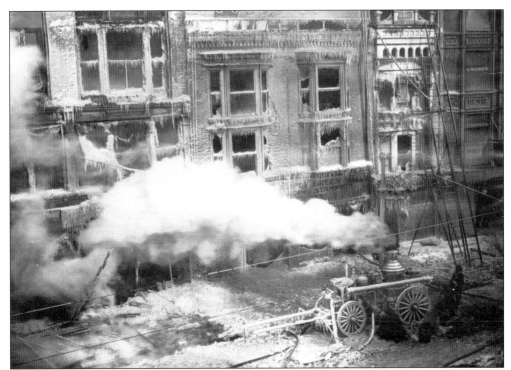

On Friday, February 26, 1904, at 5:15 a.m., a fire started in the elevator shaft of the Rochester Dry Goods Company, at 156 East Main Street. Alarms clanged in fire halls, teams of horses raced to the scene, their steam-pump engines boiling, and an army of firemen arrived to fight the spreading flames. The Dry Goods Company appears in this photograph.

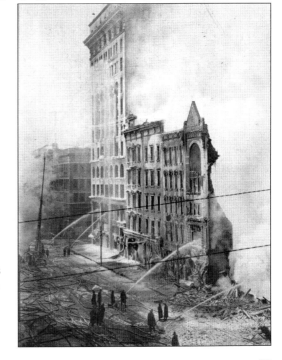

At 9:00 a.m., the Beadle Sherburne Company lived up to its prophetic second name. Only the facade of the dry goods company remains. One after one, its floors fell, pancaked together into the basement. Firemen play steady streams of water on the conflagration, as the freezing water from the tangled hoses create fantastic ice sculptures.

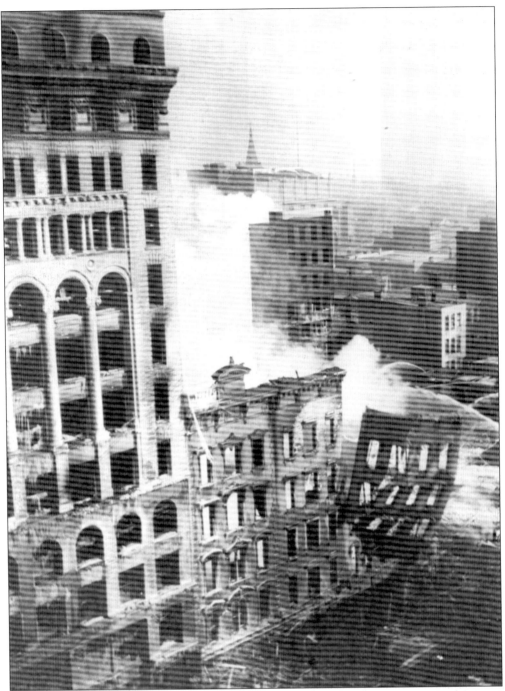

At 10:10 a.m., the tall Granite Building became the next to feel the fire's fury. The $500,000 building became a furnace, incinerating Sibley's dry goods, which were valued at $3 million. Great sections of the neighboring facades collapsed and crumbled into East Main Street,

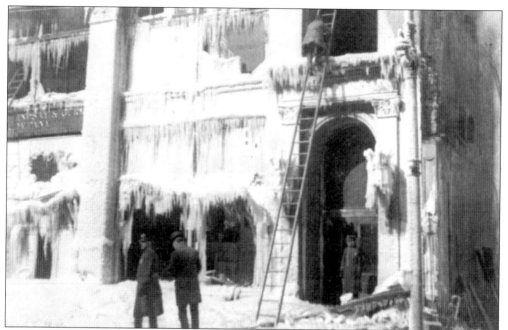

At 8:15 a.m. on February 27, 1904, the fire was finally quelled. The exterior of the Granite Building, which held Sibley, Lindsay & Curr, resembled a huge multistoried ice castle. Great rows of icicles hung from every opening. Over 3,000 employees in the retail district that encompassed the one-and-three-quarter-acre fire were out of work.

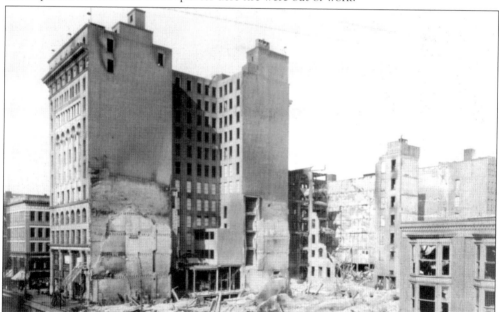

At 11:15 a.m. on Saturday, February 27, 1904, after the smoke had cleared, Rochesterians were awed by the devastation. Nearly 40 hours had elapsed since the first smoke was detected. Firemen and apparatus arrived from both Buffalo and Syracuse to fight the flames. Sibley, Lindsay & Curr's loss was $2,935,750. The total loss for all firms involved exceeded $4 million. The fire would be long remembered. To many, it was the day downtown burned.

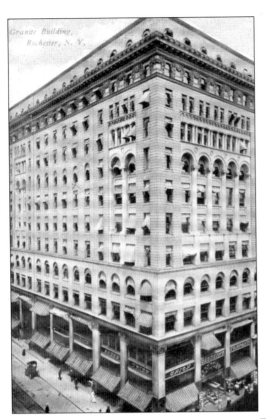

Although gutted by fire, the Granite Building's steel frame, granite walls, heavy tile floors, and iron staircases withstood the inferno. When Sibley, Lindsay & Curr moved to the old Empire Theatre Building, at Main and Clinton Streets, the Union Clothing Company became the tenant in a scrubbed and refurbished Granite Building.

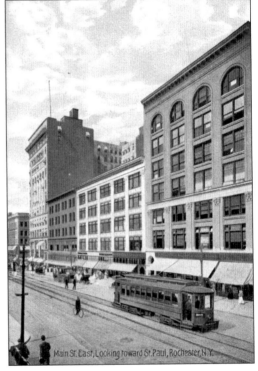

This 1908 view of East Main Street looks toward St. Paul Street. A series of new buildings have been built, replacing those destroyed in the 1904 fire. The Granite Building is on the left, and F.W. Woolworth & Company is on the right.

Rush-hour traffic during the 1937 holiday season filled East Main Street. Getting a seat on one of the New York State Railway trolleys was unlikely. Edward's Department Store is on the right. On the left, a news dealer hawked papers and magazines from a small green newsstand at the corner of St. Paul Street. (Courtesy Rochester Public Library.)

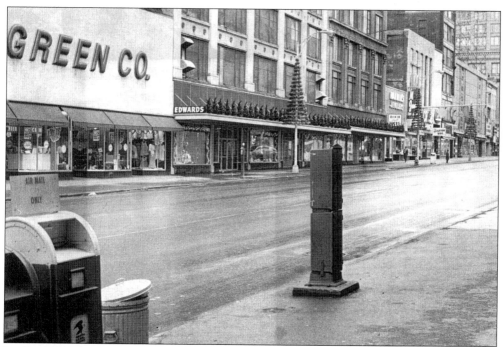

In this 1972 photograph, East Main Street is as empty of traffic as Santa's sack on Christmas morning. Edwards Department Store and the H.L. Green 5¢-to-$1 store were still popular downtown destinations for city shoppers.

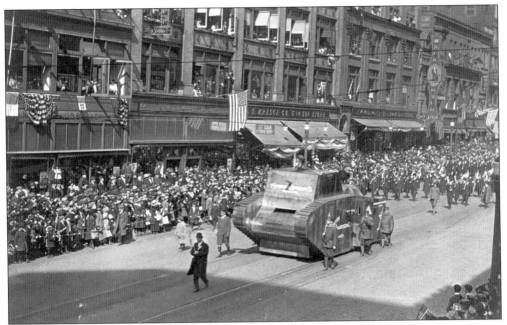

A Liberty Loan parade was staged to rally financial support. Moving west on East Main Street, the Symington-Anderson's mock-up of a tank is seen passing the E.W. Edwards Department Store. The Symington firm made ordnance shells during World War I.

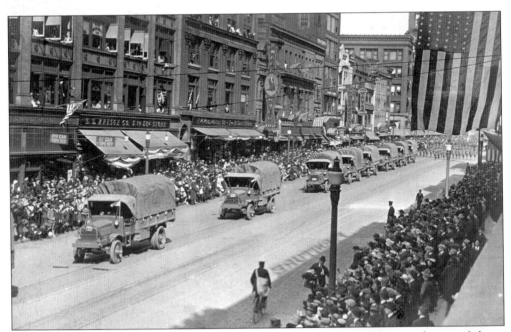

A dozen "victory trucks" roll by the S.S. Kresge Company's 5¢-to-50¢ store during a Liberty Loan parade. The trucks, built by the Selden Truck Company of University Avenue, were used in France during World War I. Note the solid rubber tires.

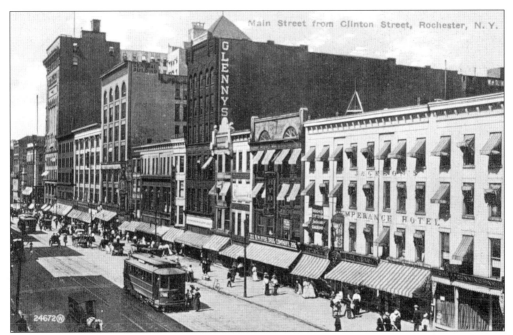

By 1911, East Main Street had become a busy shopping area. In this summer scene, awnings shade shoppers, Glenny's sells china and crockery, and teetotalers register at Jackson's Temperance Hotel.

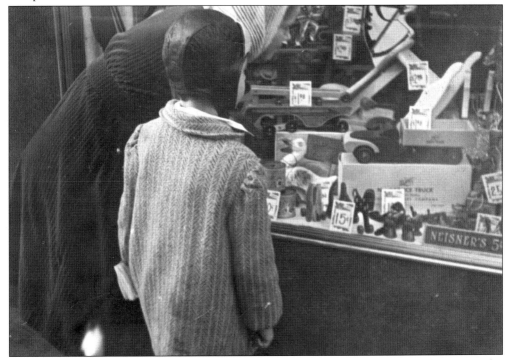

This six-year-old boy and his mother are intrigued by the toys in the window of Neisner's 5¢-to-$1 store. In December 1945, most of the toys available were made of wood, as seen here. The price of the wooden truck is $1.98.

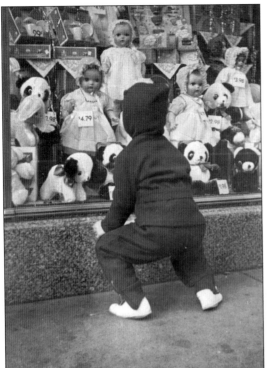

It was just prior to Christmas of 1945 when this series of photographs was taken. The little girl has fallen in love with the big beautiful doll in the pink dress. The prices in Neisner's window seem more than reasonable by today's standards.

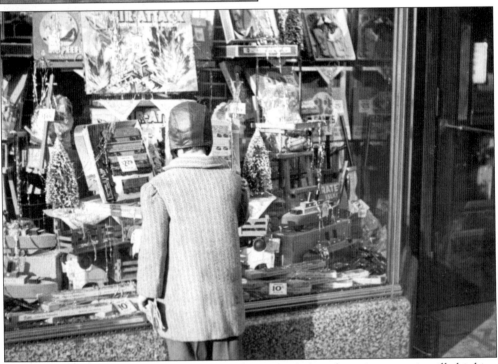

Christmas of 1945 was just five days away. The young lad in the aviator cap is still thinking about what he would like Santa to bring him. Perhaps the Air Attack game in Neisner's window is on his list.

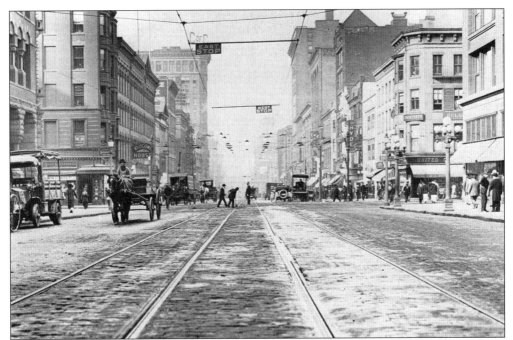

In this vintage 1910 photograph, looking west from the Clinton Avenue intersection, both horse-drawn and horseless carriages share the street. "East stop" and "West stop" signs on overhead trolley lines indicated where motormen should stop to allow passengers to alight or board. On the left, the tall Rochester Chamber of Commerce Building looms in the distance. (Courtesy Rochester Chapter NRHS Collection.)

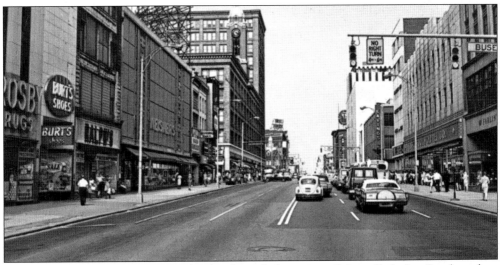

Many people recall the 1960s, the heyday of the automobile called the Beetle, when Rochester's downtown was robust, with three major department stores, four 5-and-10-cent stores, the nation's first two-level indoor shopping mall, and city buses that displayed a red-and-buff color scheme.

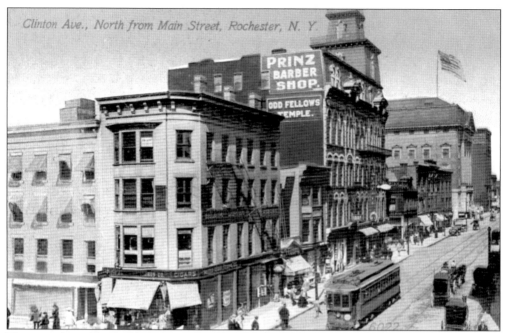

The view down North Clinton Avenue from East Main Street in 1910 includes two formidable structures. The first is the Odd Fellows Temple, at 11 North Clinton Avenue, and the second is the Masonic Temple, built in 1902, on the corner of Mortimer Street. Between 1928 and 1932, the Century-Paramount and RKO Palace Theaters replaced those two buildings.

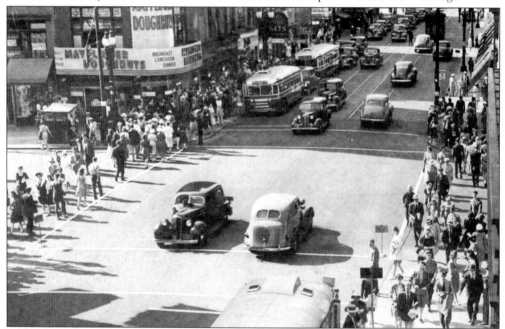

This photograph was taken in the 1930s, looking north along Clinton Avenue at the shopper-filled intersection of East Main Street. Many people can still remember eating a delicious just-made cinnamon doughnut with a cup of freshly brewed coffee at the Mayflower Doughnut Shop. (Courtesy New York Museum of Transportation.)

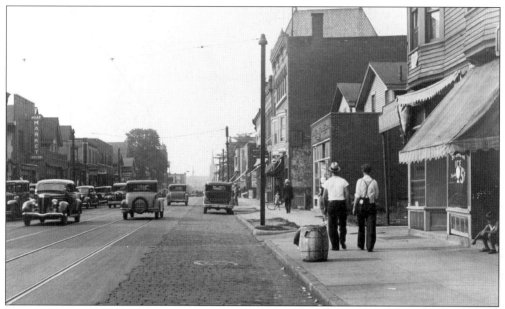

This view was taken on the muggy day of August 12, 1936, looking north along North Clinton Avenue. The spire of St. Michael's Church is in the center distance. Lincoln Hall is on the right, at No. 402, and the Oxford Bowling Hall is just beyond, at No. 406. In later years the area became a leading destination for shoppers in search of wedding dresses and other women's apparel.

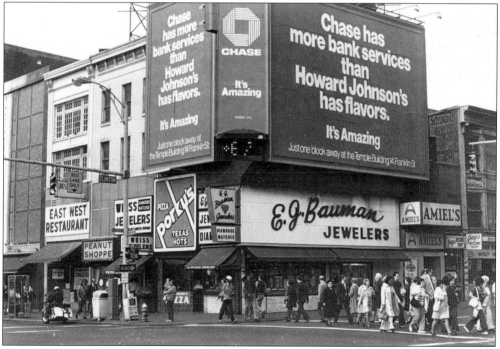

How many people remember Mr. Peanut in his peanut-tuxedo costume? Standing in front of the Peanut Shoppe near the corner of North Clinton and East Main Street, Mr. Peanut doled out free spoonfuls of hot freshly roasted peanuts to passersby.

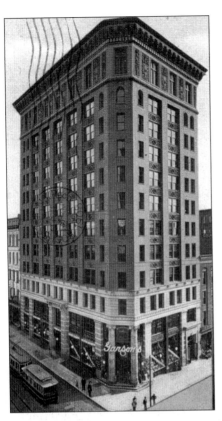

The 12-story Rochester Chamber of Commerce Building, built in 1894, was a measure of the confidence, strength, and vitality that merchants exhibited in downtown Rochester. The office and commercial building was located on the southwest corner of South Avenue.

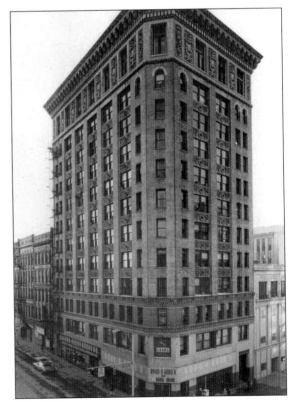

The Commerce Building was once an anchor for office and commercial business at the corner of 119 East Main Street and South Avenue. This photograph was taken for the *Walrus* on January 10, 1972. (Courtesy Landmark Society of Western New York.)

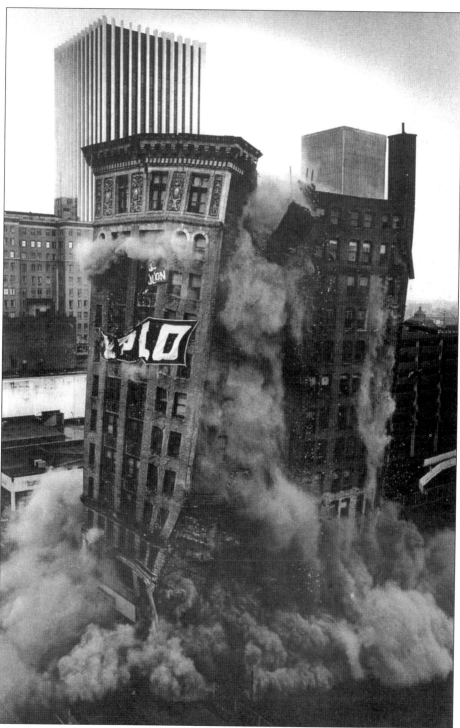

It took less than three minutes to demolish the landmark Commerce Building. Rochester's Convention Center now occupies the site. This photograph was taken by Ann Bergmanis at 11:15 a.m. on November 9, 1980. (Courtesy Landmark Society of Western New York.)

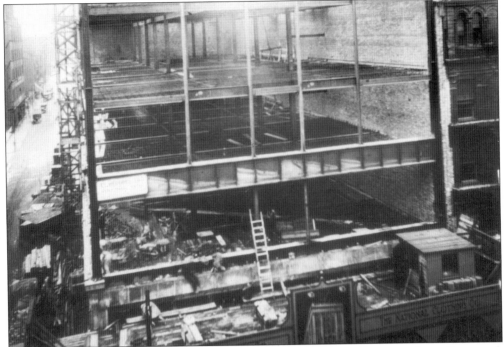

The National Clothing Company's building at 159–171 East Main Street was just a framework of girders in 1924 and 1925. (Courtesy Shaw Brothers Collection.)

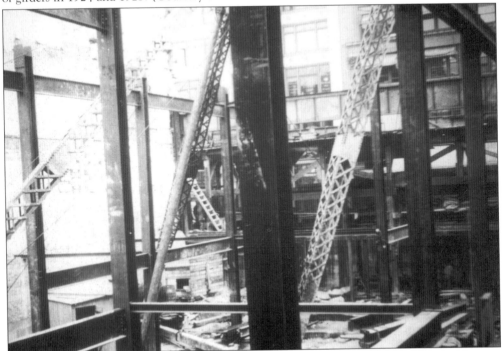

F.L. Heughes & Company erected the McFarlin Clothing Company's new building at 191–195 East Main Street. The image was recorded on July 17, 1925. (Courtesy Shaw Brothers Collection.)

Located at 165 East Main Street on the southeast corner of Stone Street, the Hotel Eggleston catered exclusively to the male population. This is a *c.* 1912 view of the hotel.

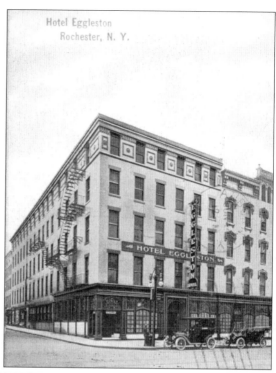

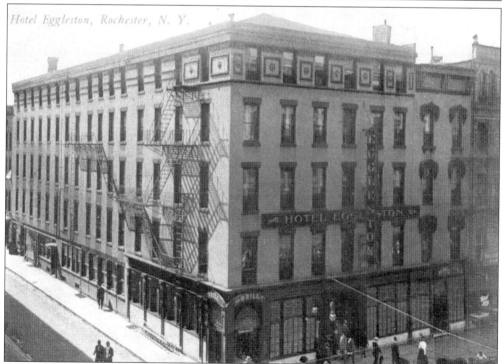

Located where Stone Street meets East Main Street, the five-story Hotel Eggleston was well known not only for its lodgings but also for its grill. It is said that horse betting was so prominent there that some patrons thought they could see hay on the saloon floor.

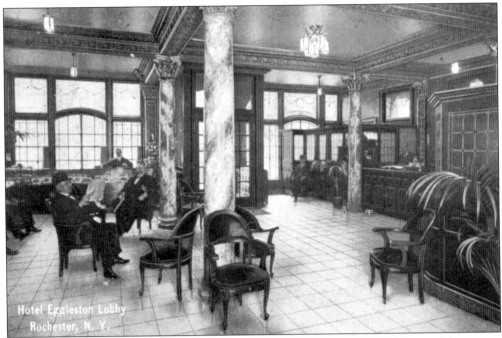

Hotel Eggleston Lobby
Rochester, N. Y.

In the Hotel Eggleston's formal lobby, one saw dozens of traveling salesmen. Many were members of a fraternity called the United Commercial Travelers.

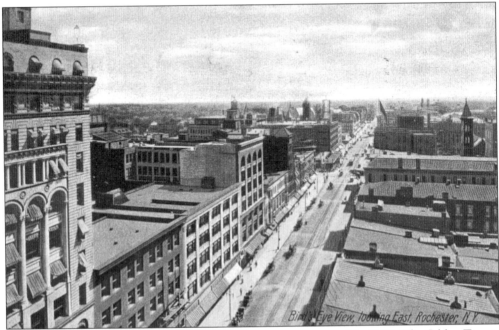

Bird's Eye View, looking East, Rochester, N. Y.

This unusual rooftop view reveals East Main Street as it appeared in 1904. The Sibley Tower, just a framework of girders at the time, is visible in the center distance. The Granite Building appears on the left.

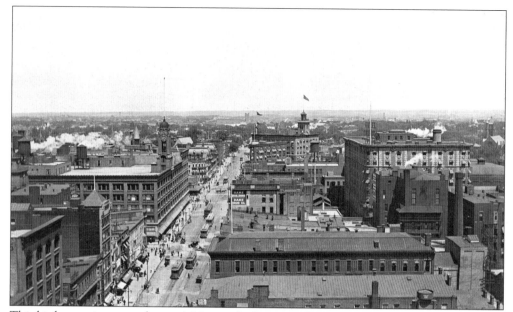

This birds-eye view was taken at 1:30 p.m., looking east down Main Street from the roof of the Rochester Chamber of Commerce Building in 1911. Note the clock on the Sibley tower. The Seneca Hotel is on the right. The Cutler Building's tower, topped with a pennant, is in the center distance. (Courtesy George Brown Collection.)

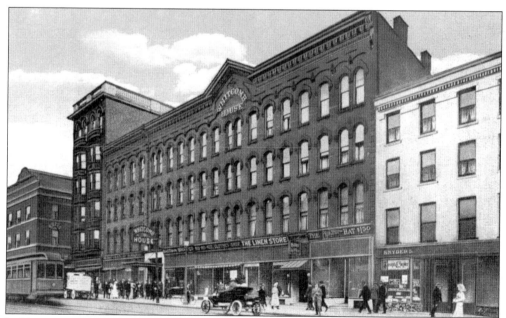

In Victorian times, one of the foremost hotels in Rochester was the Whitcomb House. Built in 1872 by Alonzo B. Whitcomb, the venerable hotel, at 213 East Main Street, was just west of South Clinton Avenue. The six-story Dake Building is to the left.

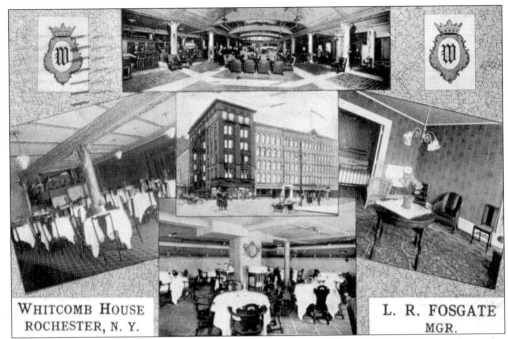

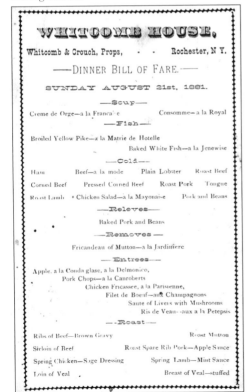

WHITCOMB HOUSE
ROCHESTER, N. Y.

L. R. FOSGATE
MGR.

This postcard was given to patrons of the Whitcomb House in 1912. It encouraged traveler interest in staying at the 200-room hotel. Note the brass bed and the formal and informal dining rooms.

WHITCOMB HOUSE,

Whitcomb & Crouch, Props, · · Rochester, N Y.

——DINNER BILL OF FARE.——

SUNDAY AUGUST 21st, 1881.

—Soup—

Creme de Orge—a la Francaise Consomme—a la Royal

—Fish—

Broiled Yellow Pike—a la Matrie de Hotelle
Baked White Fish—a la Jenewise

—Cold—

Ham Beef—a la mode Plain Lobster Roast Beef

Corned Beef Pressed Corned Beef Roast Pork Tongue

Roast Lamb • Chicken Salad—a la Mayonaise Pork and Beans

—Releves—

Baked Pork and Beans

—Removes—

Fricandeau of Mutton—a la Jardiniere

—Entrees—

Apple. a la Couda glase, a la Delmonico,
Pork Chops—a la Canroberts
Chicken Fricassee, a la Parisienne,
Filet de Boeuf—aux Champagnons
Saute of Livers with Mushrooms
Ris de Veau—aux a la Petepsis

—Roast—

Ribs of Beef—Brown Gravy Roast Mutton

Sirloin of Beef Roast Spare Rib Pork—Apple Sauce

Spring Chicken—Sage Dressing Spring Lamb—Mint Sauce

Loin of Veal . Breast of Veal—stuffed

The Whitcomb House management made a special effort to promote fine dining in the hotel's two dining rooms. The dinner bill of fare for August 21, 1881, appears to be both extensive and elegant.

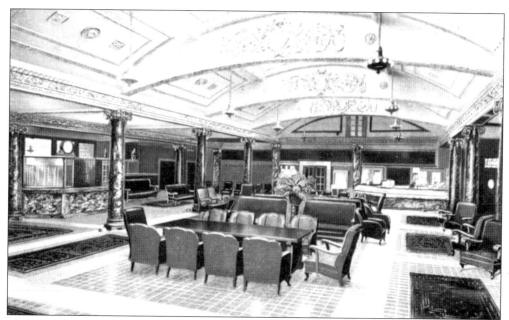

The Whitcomb House was justly proud of its generous lobby. Decorated with the Whitcomb House seal, the girders arching the lobby were said to be the largest in the city. The hotel advertised electric lights, steam heat, and elegant baths. Rates in 1905 were $2 and $2.50 per day. In 1923, the curved, arched lobby became Odenbach's famous Peacock Room.

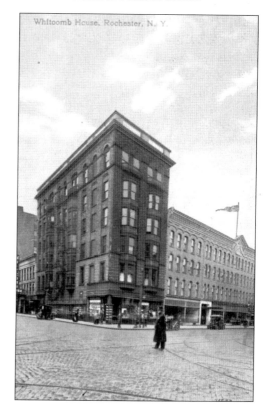

For years, Rochesterians visited the Dake Drug Company for their remedies. Operated by William and Charles Dake, the drugstore was one of the leading pharmacies in the city. It was located at 219 and 221 East Main Street, on the corner of South Clinton Avenue. The L-shaped Whitcomb House is seen both to the right and to the left in this photograph.

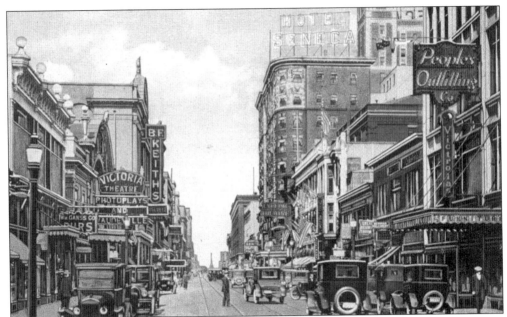

This view looks north on South Clinton Avenue *c.* 1924. On the left, two vaudeville theaters, the Temple and the Victoria, share the busy shopping area with the prestigious Lyceum Theater and the Seneca Hotel, on the right. By 1962, Midtown Plaza had replaced or incorporated the buildings on the right.

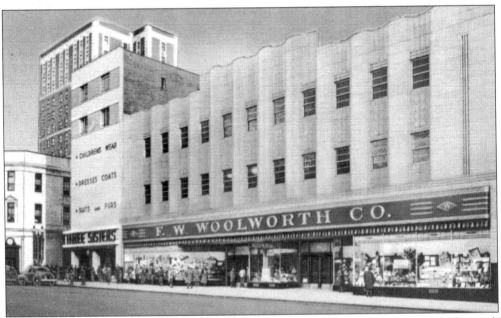

By 1947, one of the largest F.W. Woolworth stores in America had replaced the Old Whitcomb House Hotel block (the Hayward Hotel), owned by the Odenbach family. The Three Sisters replaced the Dake Building, on the corner of South Clinton Avenue and East Main Street.

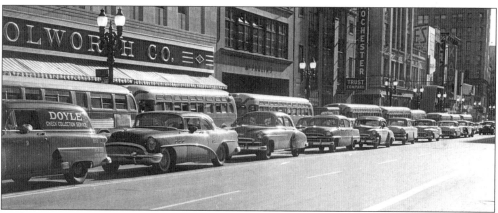

Rush-hour traffic awaits a light change near the intersection of South Clinton Avenue and East Main Street c. 1950. Buicks, Oldsmobiles, Plymouths, and Chevrolets dominate the scene. (Courtesy Landmark Society of Western New York.)

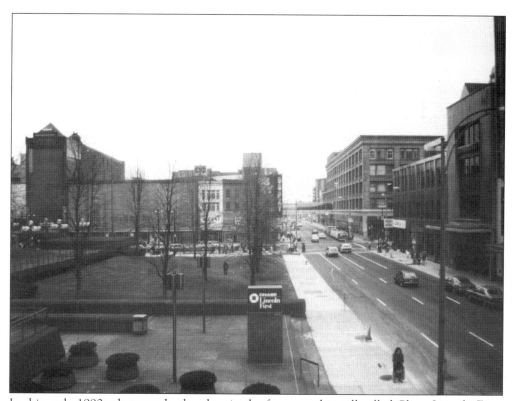

In this early-1990s photograph, the plaza in the foreground is still called Chase Lincoln First. Looking north from the bank's pedestrian bridge to the Midtown Plaza, the photograph provides a contemporary view of the intersection of East Main Street and North and South Clinton Avenues.

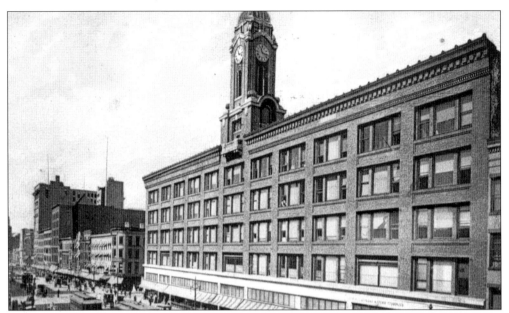

Early in 1905, Sibley's moved into its new, five-story department store. The grand opening was held in 1906. Huge display windows on the main floor attracted shoppers on Main Street and North Clinton Avenue. Within the building, 11 elevators took patrons upward, while seven Sturtevant fans provided cool the air in summer and warmth in winter. The grocery department, tearoom, and marble soda fountain were served by a 30-ton refrigerator plant. The new store was considered *the* place to shop.

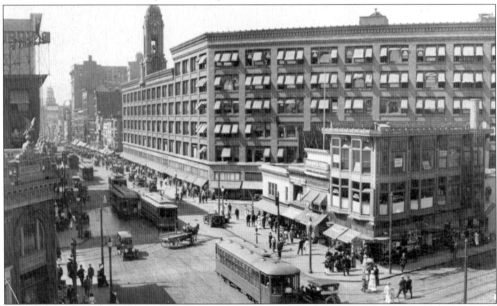

Taken from a window of the Triangle Building, this 1912 photograph looks west. Dominating the view is the six-story addition that Sibley's constructed in 1910. Called the Mercantile Building, the new section extended Sibley's length an entire block, from East Main Street to North Street. It was the heyday of downtown shopping, prior to the era of expressways and suburban shopping malls. (Courtesy New York Museum of Transportation Collection.)

Six

EAST MAIN: CLINTON AVENUE TO EAST AVENUE AND FRANKLIN STREET

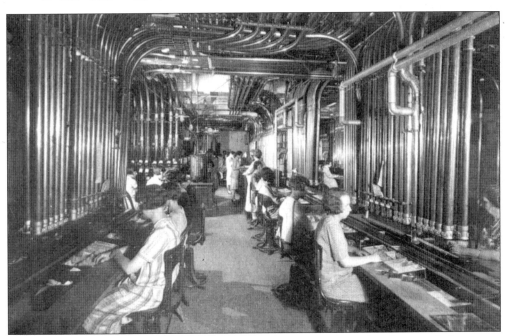

Taken from a 1926 publication, this photograph shows something that few people have ever seen: Sibley's great Tube Room. The 34 miles of tubing, the world's largest system, conveyed cash in capsules from various departments and then pneumatically returned the customer's receipts. Kids loved to hear its "whooshing" sound.

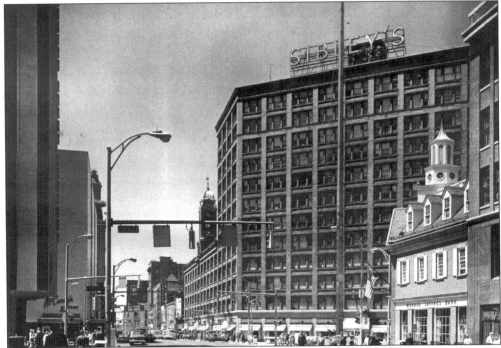

In 1926, six stories were added to the six-story Sibley Mercantile Building, now called the Sibley Tower Building. At 12 stories high, 10 additional acres of floor space were added to the store area. This photograph was taken by Hans Padelt in May 1972. (Courtesy Landmark Society of Western New York.)

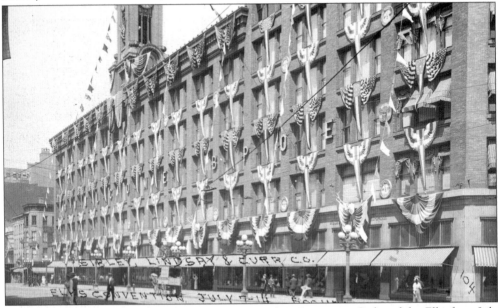

When Rochester held a convention for the Benevolent Protective Order of the Elks from July 7 to 14, 1911, the event really made a splash along Main Street. Among those ready for the Elk's mammoth parade is the Sibley, Lindsay & Curr Company, hidden behind all the patriotic banners and elk heads.

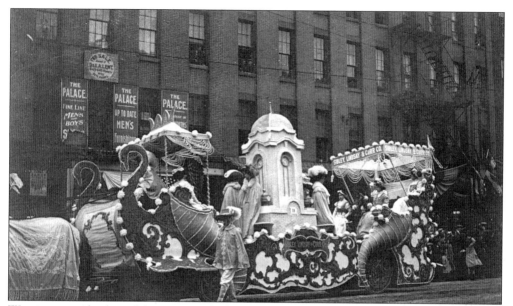

Wearing ostrich-plumed hats, ornately-dressed paraders escort the Sibley Lindsay & Curr float down Main Street. A team of blanketed horses provides the moving power for the elaborate float.

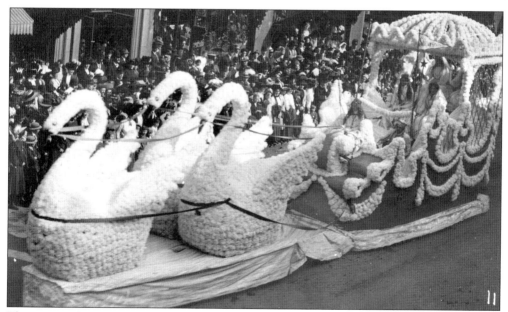

This is another Sibley's parade entry. The parade helped inaugurate Rochester's Third Industrial Exposition, on October 18, 1910. The swans are swimming down East Main Street in front of Sibley's Department Store.

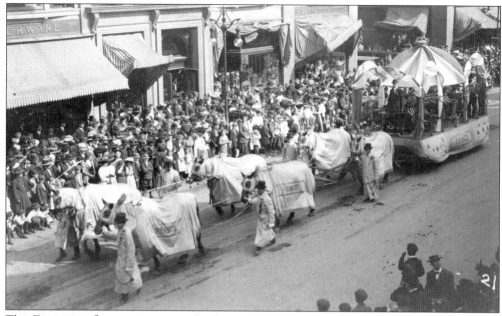

This Exposition float, representing the Prince Furniture Company, is pulled by six horses past the Willis Palliser's Engraving Shop, at 328 East Main Street.

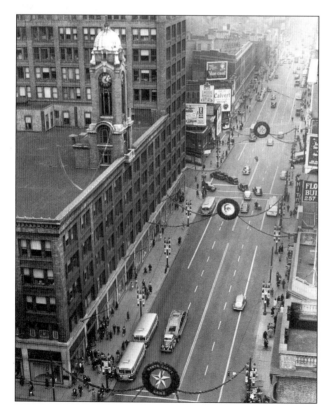

This view looks east on Main Street in November in the late 1930s. It is evident that the winter snow has not yet arrived. Main Street is all decked out, awaiting the annual Santa Claus Parade. (Courtesy Rochester Public Library.)

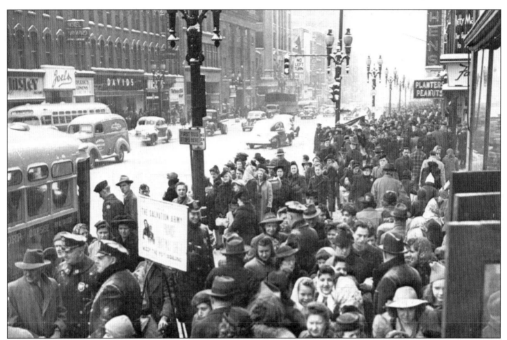

The winter snow of December 19, 1942, swirled around crowds packed on the sidewalk outside Sibley's entrance, at Main Street and North Clinton Avenue. A close study of this window into yesterday rewards one with a wartime look of downtown Rochester. (Courtesy New York Museum of Transportation Collection.)

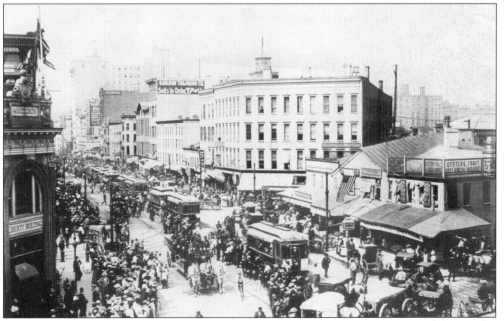

This end-of-the-19th-century photograph was taken as firemen paraded down East Main Street before turning onto East Avenue. The buildings in the center were later replaced by the Sibley Department Store. The Triangle Block is on the right. The trolley cars all in a row seem almost trapped by the large crowd of parade watchers.

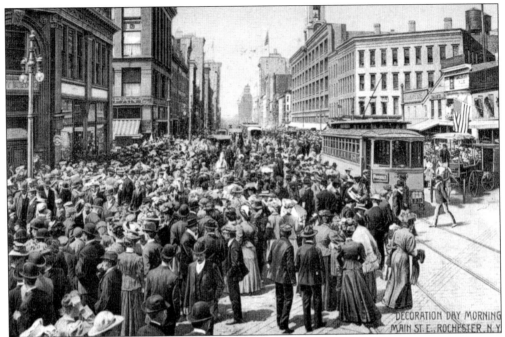

A huge crowd gathers in 1907 for the annual Decoration Day parade up East Main Street. Looking west just beyond North Street, one can see the newly built Sibley department store. The Liberty Building is on the left, on the corner of East Avenue and Main Street.

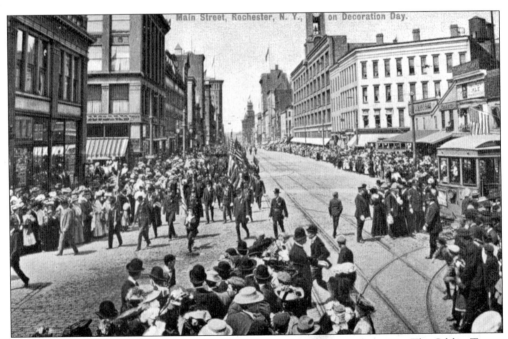

This photograph was taken just after the 1907 Decoration Day parade began. The Sibley Tower clock shows the hour is 10:10 a.m. Civil War veterans made up a part of this parade. The tribute to fallen war heroes is observed as Memorial Day today.

Perhaps the largest crowd of Rochesterians ever assembled gathered at the intersection of East Avenue and Main Street on November 11, 1918, to celebrate the end of the World War I. This rare photograph looks northwest. (Courtesy Fran Warburton.)

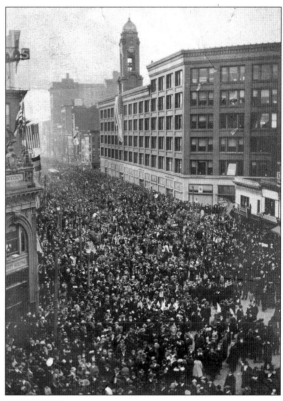

Long a public-spirited city, Rochester proclaimed its patriotism by erecting a Liberty Pole in 1848. A new shaft replaced the original Liberty Pole on April 20, 1861. In the 1880s, the building behind the pole was known as the Stillson Block.

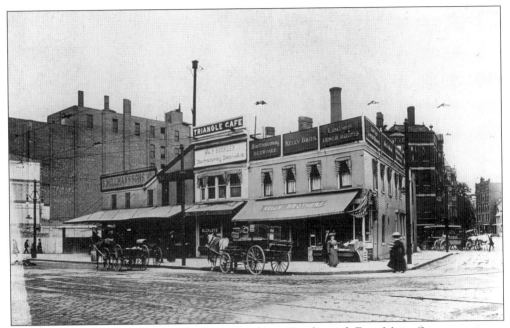

A landmark triangle was formed where Franklin, North, and East Main Streets met one another. Once a farmer's market, the triangle became the home for three enterprises in the 1890s: S. Millman & Son's fruit and fish and vegetable market, William Buckley's Triangle Cafe, and Kelly Brothers' restaurant and saloon. (Courtesy Rochester Public Library.)

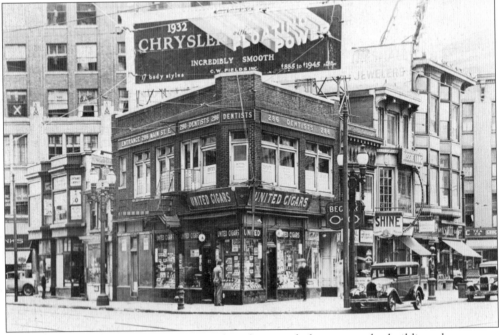

Taken on a warm summer day in 1932, this photograph focuses on the building cluster once known as the Triangle Block. Crammed with shops when the photograph was taken, the tiny block is the site of Liberty Pole Plaza today. (Courtesy New York Museum of Transportation Collection.)

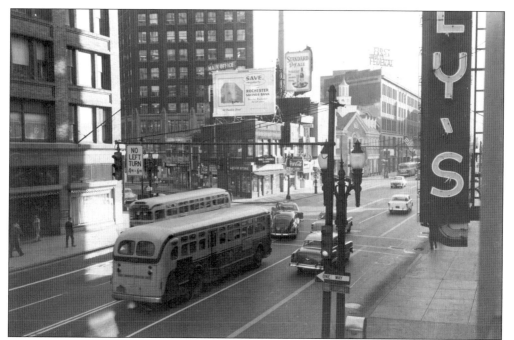

City buses share the intersection of East Main, North, and Franklin Streets in this late-1950s photograph. Close inspection of the scene reveals a variety of car models and makes, including a Studebaker. Likely's luggage store is in the foreground.

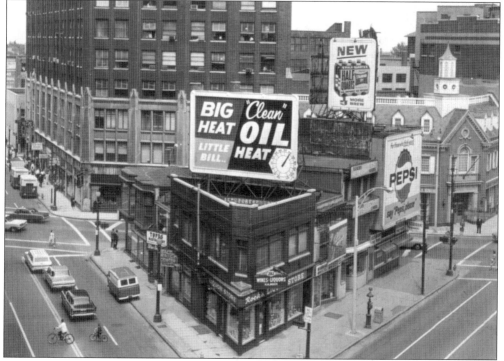

The Temple Building and Monroe County Savings Bank fill the background of this *c.* 1963 photograph of the Triangle Block. (Courtesy New York Museum of Transportation Collection.)

Once called Liberty Pole Green, the buildings in the former triangle were razed to make way for a space frame, a new polelike structure designed by James H. Johnson. The green also showcased a combination eternal flame and fountain. Neither worked for long, and someone soon turned off the water. The "eternal flame" has also gone out.

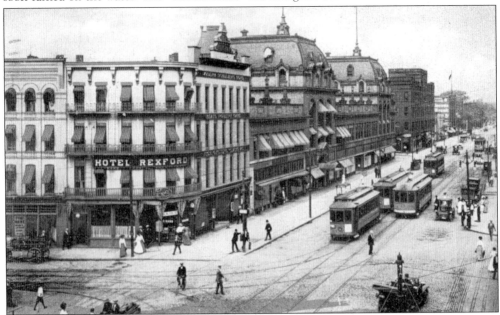

Few remember the Rexford Hotel at 310 East Main and Franklin Streets. It was a popular uptown location in 1909. To the east, the five-story buildings with mansard roofs were built by Hiram Sibley.

110

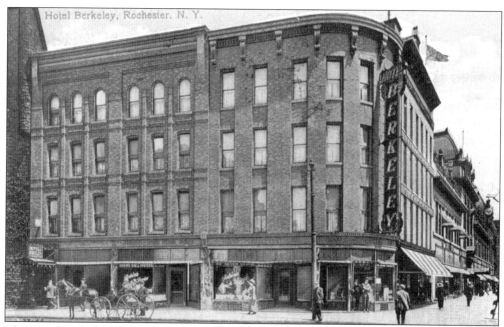

The Hotel Berkeley replaced the old Hotel Rexford at 8 Franklin Street. It opened March 15, 1913, and had 100 rooms. Lodging was 75¢ and up. The iron railings were removed and the hotel expanded into a neighboring block on Franklin Street. To the left can be seen downtown's Second Baptist Church.

Replacing the old hotels on the corner of Franklin and East Main Streets was the Monroe County Savings Bank, built in Georgian-Colonial style in 1955. Established in 1850, it was the second oldest bank in western New York. The Temple Building is on the left.

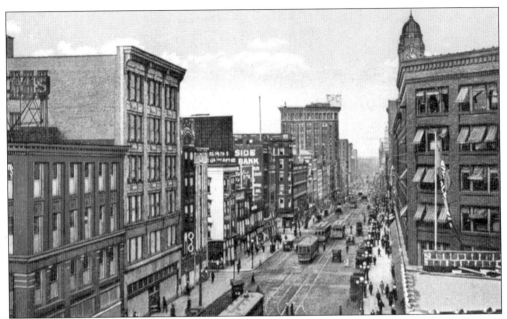

Streetcars were still the major source of public transportation in 1918. This view looks west along East Main Street from Franklin Street. The Rochester Chamber of Commerce Building is the tall structure in the distant center of the photograph.

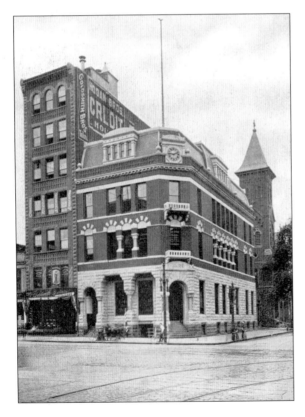

The East Side Savings Bank was located on the southeast corner of East Main and South Clinton Streets, as shown in this early-20th-century photograph. The bank, located at 223 East Main, purchased the site from the Asbury Methodist Church in 1883. Just beyond the bank is the spire of the Universalist church. Goldsmith Brothers Tailors occupied the shop east of the bank.

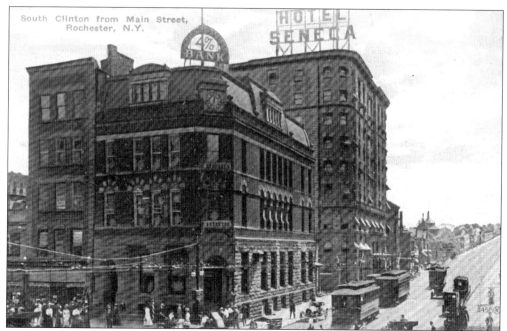

In 1906, the Universalist church property was sold to the Seneca Hotel Corporation. During 1907, the Universalist Society built a church, designed by Claude Bragdon, on the southeast corner of Court and South Clinton Streets. The newly built 550-room Seneca Hotel rises above the bank. Visible in the distance is the domelike structure of the new Universalist church.

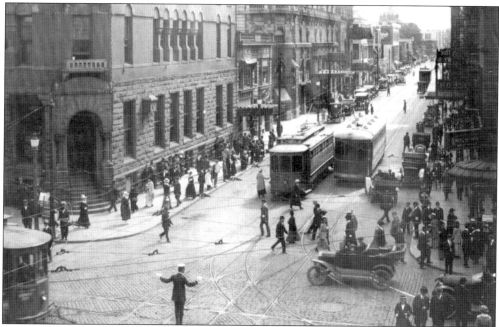

Pedestrians, street cars, and motor traffic crowd the intersection of East Main Street and South Clinton Avenue. The white-gloved police officer looks competent for the task. (Courtesy New York Museum of Transportation Collection.)

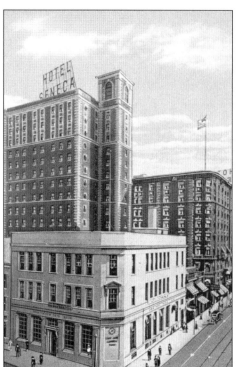

The old gray stone and red bricks on the outside of the East Side Savings Bank were replaced with a more modern facade in 1920. By 1944, the business become the Community Savings Bank. It gave a new look to that part of East Main Street.

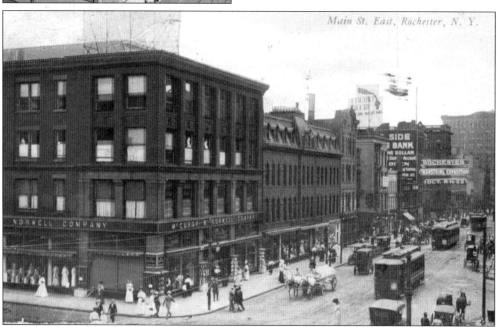

The four-story red brick building in the center of the photograph is the McCurdy-Norwell Company. Located on the southwest corner of Elm Street and 275 to 291 East Main Street, this department store first opened on March 20, 1901. The three-story building with the mansard roof (seen in the west) was also a part of the store. In 1918, it became simply McCurdy & Company. In April 1962, as a part of the Midtown Plaza, the store grew to 10 times its original size.

Seven

EAST MAIN: EAST AVENUE AND FRANKLIN STREET TO GIBBS STREET

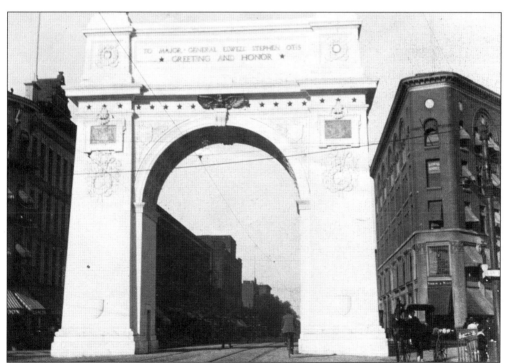

At the intersection of East Avenue and East Main Street, proud Rochesterians built a triumphal arch for their returning hero of the Spanish-American War, Maj. Gen. Elwell Stephen Otis.

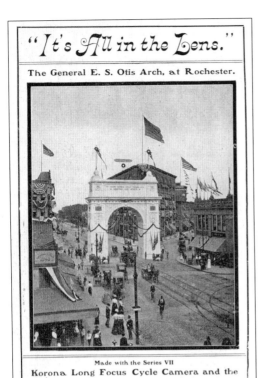

The Otis Arch was designed by J. Foster Warner and was built by Thomas Finucane. At 50 feet high and 48 feet wide, the arch had enough room to allow the passage of two trolley cars beneath its opening. The huge white structure was erected in preparation for General Otis Day, held on Friday, June 15, 1900.

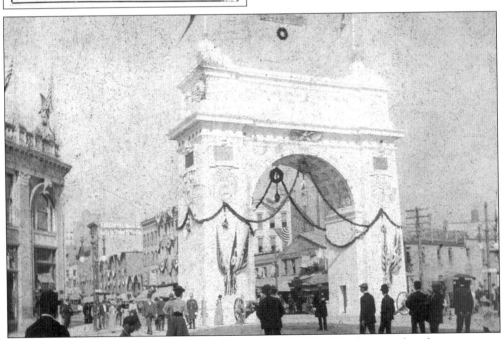

This is another view of the General Otis tribute. While the 1900 photograph is foggy, one can imagine how awed the local population must have been upon first viewing the imposing, flag-draped arch.

116

The reception Rochester gave its Spanish-American War hero, Maj. Gen. Elwell Stephen Otis, had perhaps the greatest turnout for a returning hero before that of aviator Charles Lindbergh. The daylong parade included units from the New York State Militia, seen passing along a bedecked East Main Street, in front of the Whitcomb House Hotel. Umbrellas were used for protection from the sun.

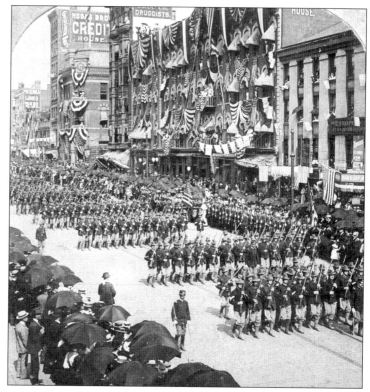

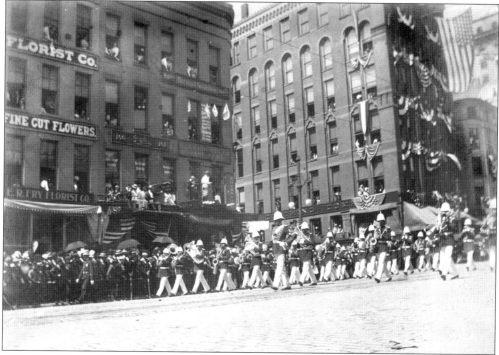

Among the marchers in the lengthy parade honoring Otis was the U.S. Marine Band. The unit is seen passing the E.R. Fry Florist Company, at 228 Main Street.

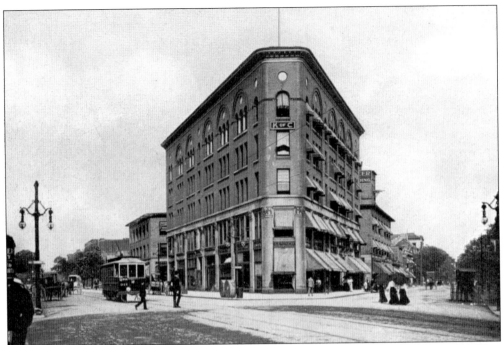

Two buildings can be seen in this 1900 photograph. The Triangle Building at the corner of East Avenue and East Main Street neatly fits in downtown's Main Street commercial and office building district. The Cutler Building, built in 1896 by brothers James and J. Warren Cutler, is seen just south of the Triangle Building, down East Avenue. Note that the Cutler Building has only three stories in this view.

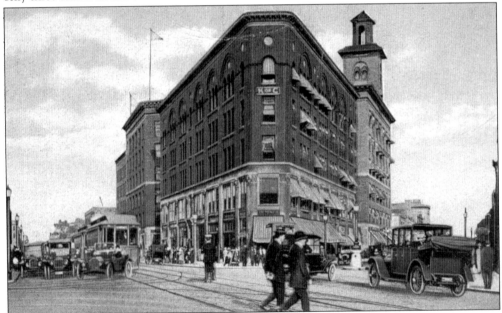

By the early 1920s, the intersection of East Avenue and Main Street had changed dramatically. Notice that the Cutler Building, with its tower, has become a six-story building, extending from 42 East Avenue to 373 East Main Street, with entrances on each street.

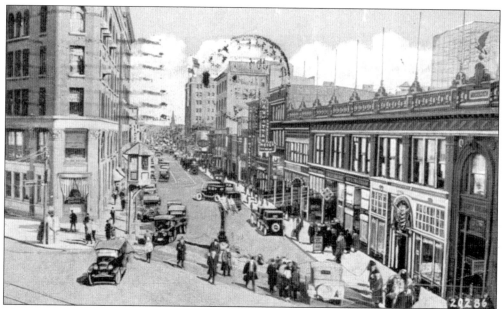

This is a view of the intersection of East Main Street and East Avenue as it looked in the late 1920s. The Liberty Building is on the right, and the Triangle Building is on the left. Note the traffic control tower. A standard bearing flags is in the center of the photograph, which looks down East Avenue.

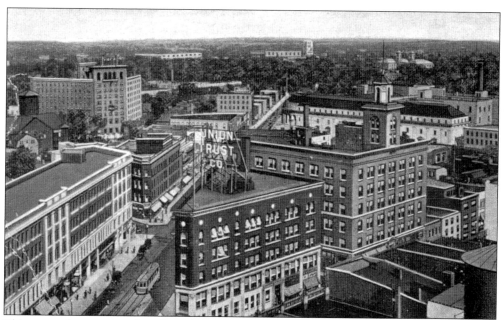

This unusual view was taken from the roof of the Seneca Hotel in the late 1920s. Scrantom's Book Store is in the lower left, on East Main Street, with the YMCA in the background. The Triangle Building (Union Trust Bank Company) and the Cutler Building are in the foreground, along East Avenue.

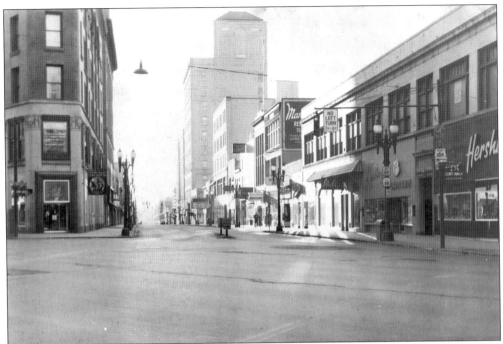

The sun was streaming brightly down East Avenue on this early Sunday morning in 1950. The intersection of East Avenue and Main Street looks much different today. The Triangle Building, on the left, is now occupied by offices of Rochester Gas & Electric.

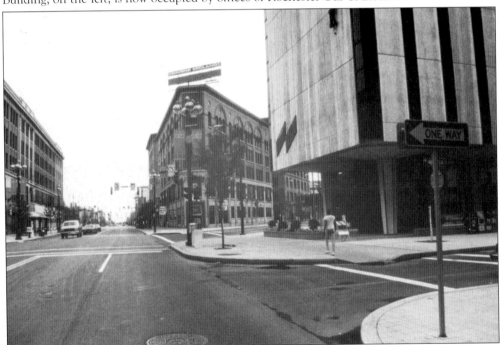

The intersection of East Avenue and East Main Street is seen from Elm Street on a quiet Sunday morning in the early 1990s. Today, the streetlights are updated and new architecture blends with the old. The rumble of the old Main Street trolleys has become a memory for a few.

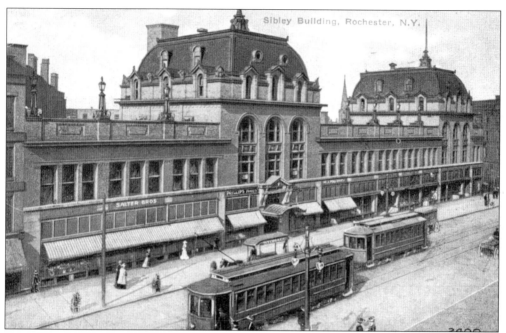

Hiram Sibley, of Western Union fame, built an impressive, nearly-block-long building. The distinctive facade and double-mansard roofs made the building an attractive addition to East Main Street. The Salter Brothers were prominent florists at the start of the 20th century. Scrantom's Stationery & Book Store occupied this site for many years.

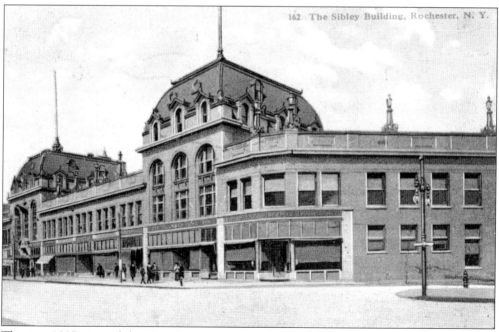

162 The Sibley Building, Rochester, N. Y.

This is a 1907 view of the Victorian-era Sibley Building. Stillson Street is on the right. The Book-Hunters Shop was one of its fashionable tenants.

121

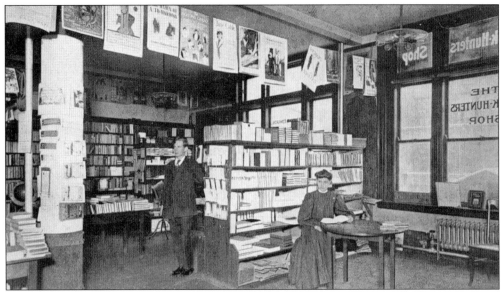

Within the gracious Hiram Sibley Building was the popular Book-Hunters Shop. In the past, as well as more recently, the building has undergone extensive changes.

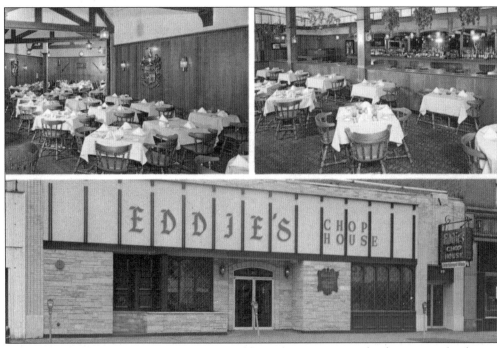

Just beyond East Avenue, at 367 East Main, Eddie's Chop House was the destination for theater patrons, as well as for casual diners. In 1923, Eddie Borghi opened the restaurant in the basement of the National Clothing Company. On December 9, 1963, Eddie's Chop House moved to the renovated Mohican Market site, on East Main Street. The Appellate Division Law Library of New York State occupies the location today.

Eight
EAST MAIN: GIBBS STREET TO GOODMAN STREET

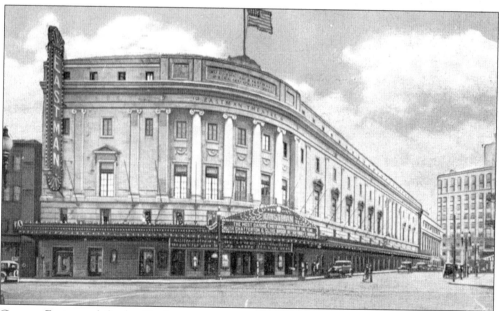

George Eastman left the Rochester community with a rich legacy of music, as well as photography. He gave the University of Rochester the Eastman Theatre, located at 425 East Main Street, on the corner of Gibbs Streets. Opened on September 4, 1922, Labor Day, the theater is home to the world-famous Rochester Philharmonic Orchestra. It was built "for the promotion of musical interests" and to showcase the best of cinematic works.

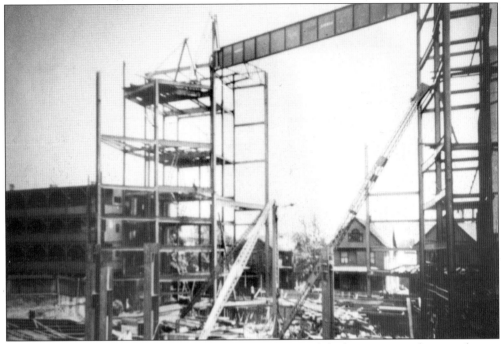

It was June 17, 1921, when F.L. Heughes & Company raised the huge stage girder into place at the Eastman Theatre. (Courtesy Shaw Brothers Collection.)

PROGRAMME

NOTICE: This Theatre, with every seat occupied, can be emptied in less than three minutes. Choose NOW the EXIT nearest to your seat, and in case of fire walk (do not run) to that EXIT.
HARRY J. BAREHAM, *Commissioner of Public Safety.*

EASTMAN THEATRE

Main Street East and Gibbs Street
Telephone, Main 7140

Performances De Luxe

At 2:15, 7:00 and 9:00 P.M.
Daily Performances continuous 1:00 to 11:00
Sundays 2:00 to 11:00

PROGRAMME

Week Beginning September 4th, 1922

A. OVERTURE "1812" by *Tschaikowsky*
EASTMAN THEATRE ORCHESTRA
ARTHUR ALEXANDER AND VICTOR WAGNER, *Conductors*

Written to commemorate the withdrawal of Napoleon from Moscow in 1812, when, after he had occupied the Kremlin, the inhabitants fired the city, and drove the French general out. Three easily recognized themes form the principal material of the overture, the first, in solemn harmony, being taken from the Russian hymn, "God Preserve Thy People," the second, the "Marseillaise," and the third, the Russian National Anthem.

(AT 2:15; 7:00 AND 9 P.M.)

B. EASTMAN THEATRE CURRENT EVENTS

C. MUSIC INTERPRETED THROUGH THE DANCE
(a) "Russia" . . . *Rachmaninoff* (G. Minor Prelude)
(b) "The South at Work" *Dvorak* (Humoresque in A. Minor)
ESTER GUSTAFSON
(AT 2:40; 7:30; AND 9:30 P.M.)

PROGRAMME

CONTINUED

D. EASTMAN THEATRE MAGAZINE
An interesting group of short pictures edited by THE EASTMAN THEATRE MANAGEMENT, including for the first time on any screen portraits in color by the EASTMAN KODACHROME PROCESS. "Film Fun" from *The Literary Digest*, "Out of the Ink-Well," the Smartest of Cartoon Comedies, Movie Chats, etc.

E. VOCAL SELECTION
"The World is Waiting for the Sunrise" . . . *Seitz*
MARION ARMSTRONG, *Scotch-Canadian Soprano*
(AT 3:00; 7:40; AND 9:40 P.M.)

F. Metro Pictures Corporation presents
THE PRISONER OF ZENDA
(precisely as now shown at $1.50 prices at Astor Theatre, New York.)
From the novel by ANTHONY HOPE
Featuring LEWIS STONE and ALICE TERRY
Produced by REX INGRAM
With an all-star cast including ROBERT EDESON

G. ORGAN EXIT
DEZSO D'ANTALFFY and JOHN HAMMOND . *Organists*
NOTE: The programme is subject to change at any time without notice, and the foregoing time schedules are approximate and intended merely for the guidance of our patrons.

Prices
AFTERNOON—Orchestra, thirty cents; Mezzanine, fifty cents; Loges, forty cents; Grand Balcony, twenty cents. No war tax.
EVENING—Orchestra, fifty cents; Mezzanine, $1.00; Loges, seventy-five cents; Grand Balcony, thirty-five cents. No war tax.

Coming Next Week
First Public Showing of GEORGE ARLISS in
"THE MAN WHO PLAYED GOD"

The original program, given to patrons at the opening of the Eastman Theatre in 1922, reveals George Eastman's wish that his theater promote both musical enrichment and the foremost in motion pictures. The Eastman Theatre Orchestra accompanied the early silent films.

This building is no longer at 420 East Main Street, on the northeast corner of Gibbs Street. The 1950s photograph shows that the building was once home to the arts, including music, dance, and paint. (Courtesy Landmark Society of Western New York.)

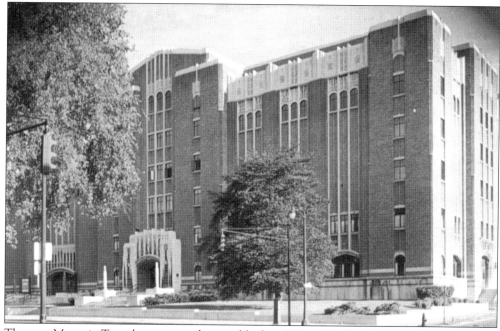

The new Masonic Temple occupies almost a block at 875 to 891 East Main and Prince Streets. The beige brick structure, designed by architect Carl Ade, cost $2.5 million. It was dedicated on May 24, 1930. The Masonic Temple later became the Masonic Auditorium, the Civic Auditorium, the Auditorium Theatre, the Auditorium, and the Center, as it is called today.

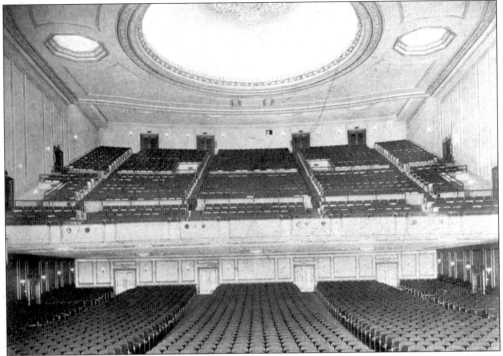

Each year thousands of Rochesterians travel down East Main Street to enjoy the recital series presented by the Rochester Theatre Organ Society in the Auditorium.

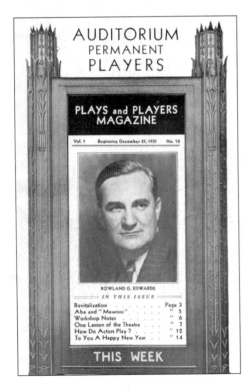

Rochester has always had a stock of talented thespians. A company of local actors created the Auditorium Permanent Players in 1931. The players were so well organized they even had their own publication, *Plays and Players Magazine*. Rowland G. Edwards was director of the Auditorium Permanent Players.

Not only are Masonic services held in the building (originally, the Masonic Temple), but the Auditorium has long been a site where local citizens can appreciate Broadway shows brought by national companies to the city. In 1937, Tallulah Bankhead starred as Cleopatra in William Shakespeare's *Antony and Cleopatra*.

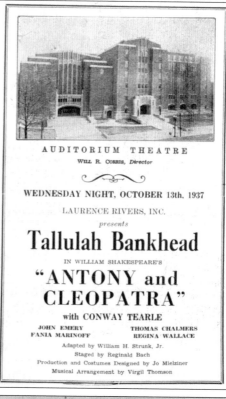

AUDITORIUM THEATRE
WILL R. CORRIS, *Director*

WEDNESDAY NIGHT, OCTOBER 13th, 1937

LAURENCE RIVERS, INC.

presents

Tallulah Bankhead

IN WILLIAM SHAKESPEARE'S

"ANTONY and CLEOPATRA"

with CONWAY TEARLE

JOHN EMERY THOMAS CHALMERS
FANIA MARINOFF REGINA WALLACE

Adapted by William H. Strunk, Jr.
Staged by Reginald Bach
Production and Costumes Designed by Jo Mielziner
Musical Arrangement by Virgil Thomson

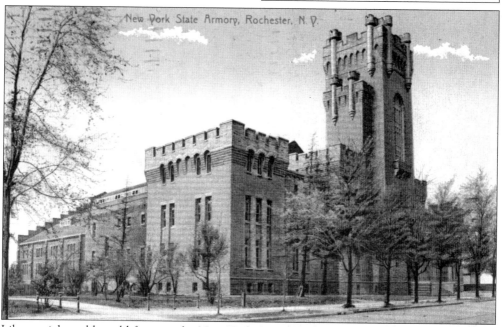

Like a mighty old-world fortress, the New York State Armory overshadowed its neighbors for years. Located at 880 East Main Street, the building was used for sporting events, the Shrine Circus, and as the National Guard's storage depot and training center. It replaced the armory at Washington Square.

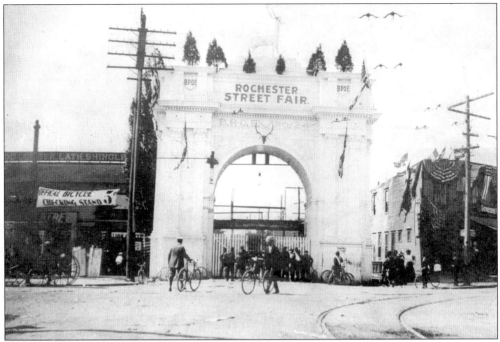

One of the most elaborate celebrations ever held in the city was the Rochester Industrial Fair and Street Carnival held August 7–12, 1899. It was located on Fair Street with an entrance at Goodman and East Main Streets. The carnival was a joint venture between the Elks Lodge and the Chamber of Commerce. A huge parade with week-long events on Fair Street ended with a dramatic, watery plunge by "Barns's famous diving elks."

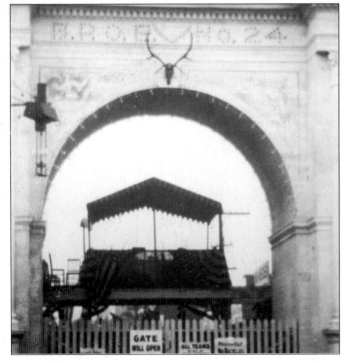

A closer look at the Rochester Street Fair entrance arch shows a bandstand covered by an awning. Each evening, the band played stirring march music to greet throngs of fair-goers. As the 200-plus images in this history have illustrated, Rochester's downtown has clearly enjoyed a productive and eventful past. We hope you have enjoyed the memories.